The Campus History Series

GENESEE
COMMUNITY COLLEGE
THE FIRST 50 YEARS

The Campus History Series

GENESEE
COMMUNITY COLLEGE

THE FIRST 50 YEARS

LARRY D. BARNES AND RUTH E. ANDES

Best wishes from Larry Barnes & Ruth Andes

ARCADIA
PUBLISHING

Published by Arcadia Publishing
Charleston, South Carolina

Printed in the United States of America

Library of Congress Control Number: 2016941033

For all general information, please contact Arcadia Publishing:
Telephone 843-853-2070
Fax 843-853-0044
E-mail sales@arcadiapublishing.com
For customer service and orders:
Toll-Free 1-888-313-2665

Visit us on the Internet at www.arcadiapublishing.com

We dedicate this book to the trustees, administrators, faculty, students, and members of the community who have contributed to the success of Genesee Community College.

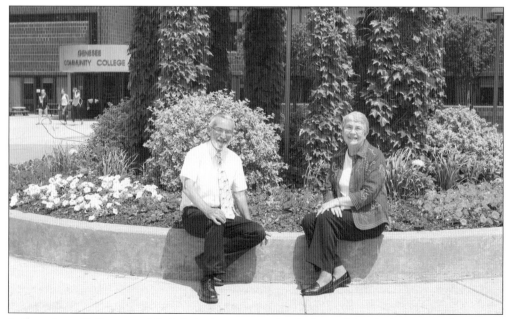

Authors Larry D. Barnes and Ruth E. Andes are seated at the base of the clock tower on the Batavia campus. (Courtesy of Genesee Community College.)

CONTENTS

ACKNOWLEDGMENTS

As with all projects of this sort, there have been many people behind the scenes who have made significant contributions for which we are very grateful. We want to single out in particular Richard Ensman Jr., Genesee Community College (GCC) director of development and external affairs; Cindy Hagelberger, GCC instructor/reference services librarian; Cindy Francis, GCC professor/collection development librarian; Donna Rae Sutherland, GCC associate director of marketing communications; and Judy Stiles, assistant to the Genesee County historian. In addition to these individuals, many other current and past administrators, faculty, and staff have generously given of their time in providing information critical to the completion of this book.

Unless otherwise noted, all images appear courtesy of Genesee Community College.

INTRODUCTION

The history of Genesee Community College (GCC) is highly unusual. In New York State, the establishment of a community college requires local initiative. Normally, this initiative comes from political leaders, typically a county legislature. However, in Genesee County, there was no initiative of this sort. In fact, it would be fair to say that political leaders were initially unsupportive, even actively opposed, to the establishment of a community college. The ultimately successful effort to establish a community college in Genesee County was a grassroots movement. The process was bottom up rather than top down in nature. This in itself is remarkable. However, what is even more remarkable is that in the face of this grassroots movement, the county's political leadership eventually came to follow the lead of its constituents and some who had opposed the college became among Genesee Community College's strongest supporters.

The details of the history leading up to the establishment of Genesee Community College could be difficult to discover 50 to 60 years later except for another uncommon occurrence. In the late 1960s, this early history was the subject of a doctoral dissertation at the State University of New York at Buffalo. This dissertation was written by David E. Peters, who served as a dean of students at GCC. A condensed version of the dissertation, titled *The Founding of Genesee Community College*, was published by GCC in February 1970.

The authors of the current book are greatly indebted to Peters's work. Most of the information in this introduction and part of that in chapter 1 stem from his invaluable research.

The idea of establishing a community college in Genesee County appears to have first surfaced in the winter of 1957–1958. In March 1958, the chairman of the Genesee County Board of Supervisors appointed a nine-man study committee to investigate the possible need for a community college. This committee distributed a survey in June 1958 that was an effort to determine the number of students who might attend such a local college. Reportedly, the number was found to be very low, perhaps no more than 75 individuals. Furthermore, the study committee estimated that a community college would require a capital expenditure of around $750,000 and "a very sizeable figure" for operating expenses. In addition, it was discovered that both Erie and Monroe Counties were considering the establishment of community colleges, colleges that would be able to serve students from Genesee County. In a final report to the board of supervisors dated August 13, 1958, the study committee recommends no action at that time. The report was approved by the board, and the matter was dropped.

The next time anyone brought up the idea of a community college anywhere other than in Erie or Monroe Counties occurred in October 1961. Jerome Moberg, an industrial designer

with Robeson Cutlery Company in Perry, New York, proposed that a community college be established in Wyoming County. However, when Moberg appealed to the Wyoming County Board of Supervisors for the establishment of a committee to investigate such a college, his efforts were rebuffed. Then, in subsequent communications between Moberg and Paul Orvis, executive dean of the State University of New York, Orvis encouraged Moberg to consider advocating a tri-county college serving Wyoming, Genesee, and Livingston Counties. At this point, Moberg turned to James Beach, chairman of the Genesee County Republican Committee. After conferring with several individuals who had served on the 1958 study committee mentioned above and also conferring with Russell Gillett, current chair of the Genesee County Board of Supervisors, Beach indicated that support for a tri-county community college would not be forthcoming from Genesee.

Jerome Moberg's efforts were essentially a one-man crusade that included a 1962 publication of a booklet titled *The Case for a Tri-County Community College*. In the course of his crusade, he spent several thousand of his own dollars. However, nothing appeared to result from his efforts.

At about the same time that Moberg was unsuccessfully trying to promote the establishment of a community college in the area, the Extension Service at Cornell University was undertaking a program to improve the quality of leadership at the local level throughout New York State. Referred to as "Operation Advance," it was designed for individuals in leadership positions. The stated purpose was "to offer that kind of leadership education, for a broad and diverse group of community leaders, which will lead to more effective public action on problems of common concern." In Genesee County, 10 Operation Advance discussion groups were formed, each made up of 10 to 12 community leaders. There were two stages involved in the operation of the discussion groups. In the first stage, five topics were explored, one of which was schools. In the second stage, participants were assisted in realizing how to move beyond discussion to action.

Among the local participants in Operation Advance were several members of the Batavia Jaycees. The Jaycees consisted of relatively young men who were interested in improving the community. Most of them were professionals or managers. As a result of the Operation Advance experience among many members of their organization, in 1962, the Jaycees decided to undertake an informal community college needs study and for several weeks went about collecting relevant information. In the process, they made contacts with school officials in Orleans, Genesee, and Wyoming Counties.

In early 1963, after becoming convinced of a need for a local community college as a consequence of their informal study, the Jaycees sought a meeting with the Genesee County Board of Supervisors. At this April 1963 meeting, Jaycee Michael Ryan proposed that the supervisors and Jaycees together undertake a formal needs study. Several of the supervisors were opposed to the proposal. It has been alleged that not only did they think a college was not needed and would be too expensive in any event, but they also viewed the proposal as primarily an effort to promote the Jaycees organization. Nonetheless, the board of supervisors unanimously voted to grant the Jaycees the "privilege" of undertaking a formal study primarily working on their own. Chairman Gillett requested a list of names of potential appointees, and on April 18, 1963, he appointed a study committee. It consisted solely of Jaycees, except for the appointed chair, William Stuart. Stuart, at the time, served as the chair of the board of supervisors' committee on finance. However, in subsequent practice, the study committee was led by Jaycee Marlow Brown and Stuart's position effectively became honorary in nature.

The fall of 1963 saw the first real opposition to a community college among the county's educational leadership. That came from Hugh Vanderhoof, district superintendent for all of the county schools except those in the city of Batavia and LeRoy. Vanderhoof felt that the development of vocational training and work experience programs should have priority over a college. The notion that a choice had to be made between a college or a vocational

training institution and that the community could not support both remained in play until the eventual establishment of Genesee Community College.

By early December 1963, a rough draft of the needs study had been completed. A 78-page report was presented to the board of supervisors on February 4, 1964. On the basis of its research, the study committee concluded that there was, beyond doubt, a need for a community college and, furthermore, that the county had the financial ability to support one. At the February 4 meeting, Jaycee Michael Ryan asked the board of supervisors to become the sponsoring body for a community college. The supervisors thanked the committee for its report, and each supervisor was urged to carefully review the findings. Shortly afterwards, to the great disappointment of the other study committee members, William Stuart went on public record supporting a vocational education program rather than a college.

At this point, the Jaycees realized that they could not get the support of the majority of the 19 members of the board of supervisors. Consequently, in the spring of 1964, they undertook a campaign to win the necessary votes by educating the electorate, who, they hoped, would then put pressure on the supervisors. Perhaps as the result of such pressure, the issue came to a head in the fall of 1964. At the September 9 meeting of the board, supervisor William Taylor introduced a motion that the board of supervisors sponsor a community college. The motion was defeated by a vote of 9 yeas and 10 nays. After the defeat of the Taylor resolution, supervisor John Howe introduced a motion to allow the voters of the county to decide the issue. The resolution passed by a vote of 14 yeas and 5 nays. The Howe resolution stipulated that a binding referendum was to be held at the next general election, November 2, 1965.

The votes on the above resolutions were viewed by the Jaycees as a major defeat. It was evident that the efforts to persuade a majority of supervisors to support a college had failed. It was also understood that those who voted to turn the matter over to a public referendum in many instances were doing so because they were confident that voters would reject the creation of a community college and the issue would finally be put to rest. In fact, the supervisors who were the strongest supporters of a college had voted not to submit the issue to a public referendum. The Jaycees were also disappointed that, in their eyes, the supervisors had chosen to take the easy way out of a difficult situation.

It was now apparent that the only hope for establishing a community college was to somehow persuade a majority of voters to support such a move. In analyzing the probable voting patterns, it was expected that the strongest support would come from the more urban areas of the county. The rural areas were expected to be the least supportive. This presented a particular problem for the Jaycees, the prime movers in support of a college. It was basically a Batavia organization. In order to gain rural support, some way was needed to broaden the base of active supporters. Thus supporters reorganized under a new name, the Citizens Committee. And they sought out additional members from outlying areas. With that change, an all-out effort was mounted to secure a "yes" vote.

Opponents of a college were concerned, in part, about its impact on property taxes. However, in an unforeseen legislative action, that issue was alleviated in part by a development occurring in June 1965. For reasons unrelated to financing a college, the board of supervisors moved to create the county's first sales tax. By a vote of 13-6, on June 25, the supervisors approved a two percent retail sales tax effective January 1, 1966. Forty percent of the sales tax revenue was to go to county coffers and the remaining 60 percent was to be distributed to the city of Batavia and the various townships. It did not take proponents of the college long to point out that the county's share of the sales tax would more than cover the operating cost of the proposed college. Thus, there would be no impact on property taxes. This development made selling the college to the general public a little easier.

The decision of the board of supervisors to submit the creation of a community college to a public referendum ultimately turned out to be a game changer, but not in the anticipated manner. The political leaders in the community and on the board in particular expected voters to turn down a college, perhaps by a margin as great as five to one. However, the

outcome of the referendum was a wholly unexpected vote of support. The yeas exceeded the nays by more than 1,000 votes.

The chapters that follow are devoted to the cascade of events that subsequently occurred and continue to occur following the decision of the board of supervisors to place the creation of a community college in the hands of the voters. Chapter 1 describes the overall effort to gain voter support for a community college in the months immediately before the referendum, the specific results of the referendum held in 1965, and the subsequent beginnings of the new college in the months leading up to opening day in September 1967. Chapter 2 covers the years 1967 to 1972, when GCC operated in a renovated department store building. In chapters 3 and 4, the building of a permanent campus is described, the new areas of instruction it made possible, and the growth of additional facilities over the next 40 years. Chapter 5 features many of the curricula and cocurricular activities available to students at GCC. The college facilities initially existed only on the Batavia campus. However, as described in chapter 6, campus centers were inaugurated starting in 1990 and have expanded to six in number. The student body has grown to a number nearly 90 times larger than was predicted in the earliest studies. Chapter 7 describes the student body that evolved in the course of this amazing growth. Genesee Community College has taken the term "community" very seriously, involving itself in surrounding communities and they in the operation of the college. Chapter 8 provides multiple examples of this fact. Finally, chapter 9 addresses the future. As this book went to print, two newer facilities, both major in scope, were under construction at the Batavia campus.

One

THE BEGINNING OF A NEW COLLEGE

As indicated in the introduction to this book, the creation of a community college had been discussed locally as early as 1957. However, the Genesee Board of Supervisors, historically a politically and fiscally conservative body, was reluctant to move forward. Finally, the board, in September 1964, sought to put the matter to rest by submitting it to a binding public referendum at the general election occurring in November 1965. It was anticipated that voters would reject the creation of a community college by a margin of between three and five to one.

In the 14 months leading up to the general election of 1965, a citizens group mounted a well-organized and comprehensive campaign advocating for a "yes" vote in support of a college. The effort paid off. When the voters of Genesee County made their feelings known on November 2, 1965, the yeas outnumbered the nays by a margin of 7,730 to 6,670.

To their credit, the members of the Genesee County Board of Supervisors responded to the electorate by subsequently giving unqualified support to the creation of a community college. Eventually, some of the original opponents became among the college's strongest supporters. In February 1966, the supervisors unanimously voted to establish Genesee Community College (GCC) subject to approval by the trustees of the State University of New York (SUNY). In March, the supervisors submitted to the SUNY trustees a plan for sponsorship and operation. Then, on April 15, 1966, the SUNY Board of Trustees officially authorized the establishment of Genesee Community College.

Ordinarily, SUNY expected the process of starting a new college to take a full two years. But since an opening date of September 1967 was desired, a much-compressed schedule was undertaken. By June 1966, a board of trustees was up and running. By October, the trustees had agreed on Dr. Alfred C. O'Connell as the first GCC president. In April 1967, a temporary site and building were purchased. And by opening day, 21 faculty members had been hired.

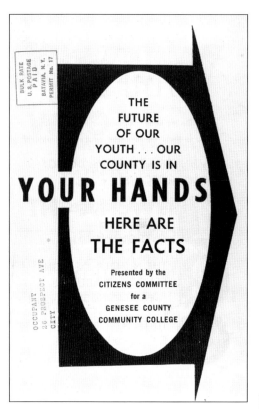

The effort to persuade voters to support the creation of a community college took many different approaches. One of them was a speakers bureau that had scheduled over 200 speaking engagements by October 1965. Another was distribution of thousands of the eight-page pamphlet in part shown here and in the next three illustrations.

One issue addressed by the pamphlet is the growing need for advanced education. It is pointed out that the educational opportunities available to local residents are no longer adequate. Thus the case is made for a local community college that could provide two-year degrees, transfer programs leading to four-year degrees, and night-school classes.

WHY ADVANCED EDUCATION ?
★ MODERN SOCIETY REQUIRES MORE EDUCATION!

WHO ?
★ HUNDREDS OF OUR CAPABLE HIGH SCHOOL GRADUATES WILL NOT GO TO COLLEGE!

THE ANSWER:
A STATE SUPPORTED 2 YEAR COMMUNITY COLLEGE HERE IN

GENESEE COUNTY!

OFFERING:
A. 2 yr. Technical Degree
B. Transfer program to 4 yr. college
C. Night School

Although the college was to be named Genesee Community College, from the very beginning, supporters made clear that the service area was greater than Genesee County alone. This was a selling point, because under state law, the home counties of students outside Genesee were required to send financial support to Genesee County.

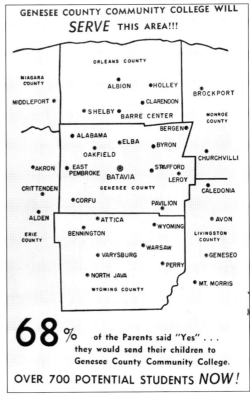

The final page of the pamphlet presents the exact wording of the proposition voters would see in the voting booth. Overall, a majority heeded the plea to vote "yes." The proposition passed by a wide margin in the city of Batavia and by smaller margins in six of the 13 townships.

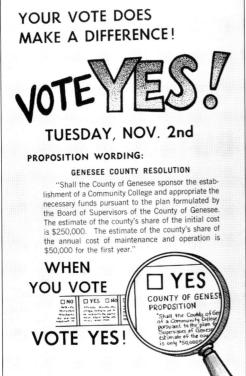

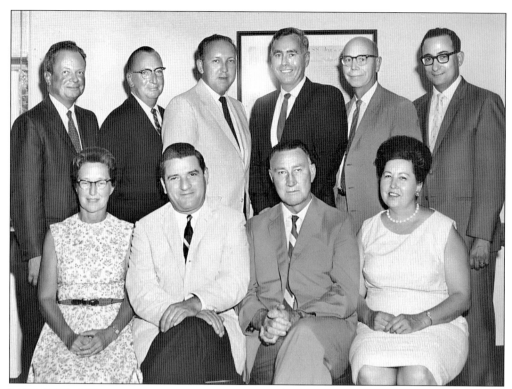

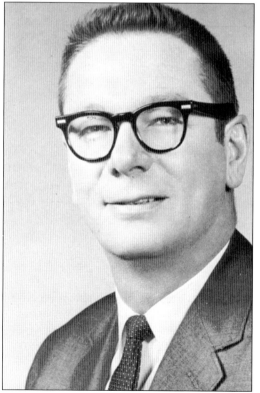

The first board of trustees is shown here along with Dr. John Mears of the State University of New York, who is second from the left in the first row. Trustees are, from left to right, (first row) Martha Jenks, Robert Fussell, and Almeta George; (second row) William Setchel, Francis Robinson, Neil Burns, Michael Ryan, Warren Dayton, and Anthony Zambito.

Dr. Alfred O'Connell was chosen by the board of trustees as the first president. One of over 30 candidates considered for the position, he was at the time president of Harford Junior College in Bel Air, Maryland. O'Connell had been suggested by Dr. Michael Brick of Teachers College, Columbia University, a recognized authority on community colleges.

For the positions of dean of students
and academic dean, O'Connell placed
a priority on persons who exhibited
teamwork and a common understanding
of issues. As a result, in December 1966,
he recommended that the board of
trustees appoint Stuart Steiner as dean
of students. Steiner had been employed
under O'Connell as director of admissions
at Harford Junior College.

As was the case with the selection of
a dean of students, O'Connell again
turned to an associate at Harford Junior
College in recommending an academic
dean. In January 1967, he recommended
Robert Trantham, who at the time was
an assistant professor in the Division
of Humanities.

The final top administrative position was filled in January 1967 by William Collins, who was appointed as the business manager. Collins was a longtime Batavia resident then serving as chairman of the business department at Batavia High School. Thus he met the need for someone who had both business experience and an intimate knowledge of the local area.

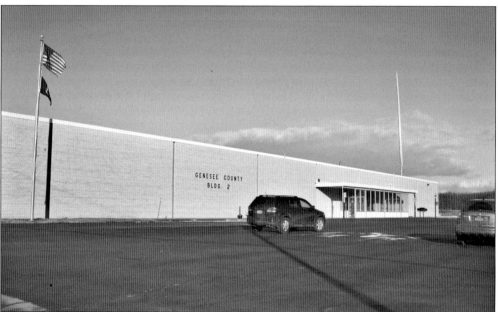

Aside from hiring a faculty, the final major step involved in establishing the new college occurred in April 1967, when the former Valu Department Store on West Main Street Road was purchased for $175,000. The V.J. Gautieri Company then undertook the necessary interior renovations. Fifty years later, the building's exterior, as shown in the recent picture above, remains unchanged except for a glass enclosure beneath the roof over the entrance.

Two

THE EARLY YEARS
1967–1972

All the planning for Genesee Community College came to fruition on September 28, 1967, with the arrival of 378 full-time and 243 part-time students on opening day. Initially, the expectation was for 100 or fewer full-time students, so greeting that many new learners reinforced the belief that a community college was needed and could be successful in Genesee County.

The renovation of the Valu Department Store successfully accommodated the several hundred students and recently hired faculty. The college opened with eight programs: liberal arts and science transfer programs in the humanities, mathematics, natural sciences, and social sciences and four career programs in accounting, business administration, data processing, and secretarial science. The next few years on the temporary campus saw continuous growth in the size of the student body and the number of programs offered. By the fall of 1971, there were 1,720 students. New programs included nursing and police science (now criminal justice) as well as a certificate in office assistant.

During these early years, there was one particularly significant change in leadership. President O'Connell, who had been so instrumental in the start of the college, resigned in 1970. Dr. Cornelius Robbins was inaugurated in October 1970 as the second president of the college. He presided over the planning for the move to the permanent campus, scheduled for January 1972.

These early years were instrumental in building a lasting foundation that sustained the college during the next several decades. It was an exciting time of growth and innovation. Many of the faculty members, often drawn from across the country, were at the beginning of their careers. A significant number of this core group remained at the college for the next several decades. This stability was further enhanced by Dr. Stuart Steiner, who had joined the college during its formation, when he became president in 1975 and remained in that office for 36 years.

The citizens of Genesee County who supported the founding of the college could not have imagined the institution as it is at its 50th anniversary. Nonetheless, it is their vision that has sustained the growth and development of Genesee Community College from that opening day in 1967.

The renovated Valu Department Store was ready for the first day of classes. This location led to the college sometimes being referred to as "Valu Tech," a designation that was not complimentary in the beginning but is today recalled with affection. Those early years on the "old campus" and being part of a new beginning are remembered by those who were present as among the most rewarding of their professional experiences.

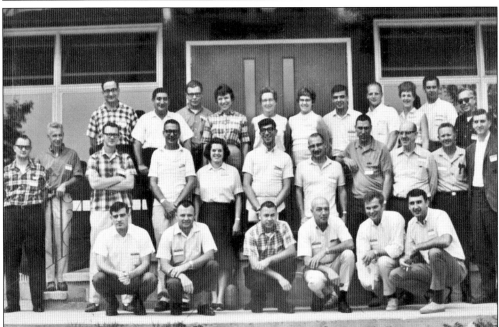

Hiring a qualified faculty was essential to the successful launch of Genesee Community College in the fall of 1967. Before classes began, a group of 28 newly hired faculty and administrators gathered for a three-day retreat to develop a shared vision for the first day of the new college. They were welcomed by President O'Connell, and the new college was underway.

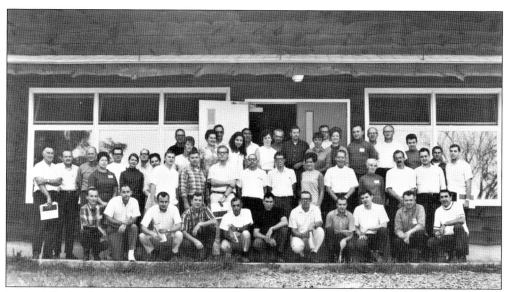

In the fall of 1968, the largest group of faculty ever to be hired at one time came together for an orientation retreat. Combined with the 1967 group, they became the early faculty leaders who established the College Senate, aided in the development of new programs, brought innovations to instruction, and voted to initiate union membership. Larry Barnes, one of the authors of this book, was a member of this seminal group.

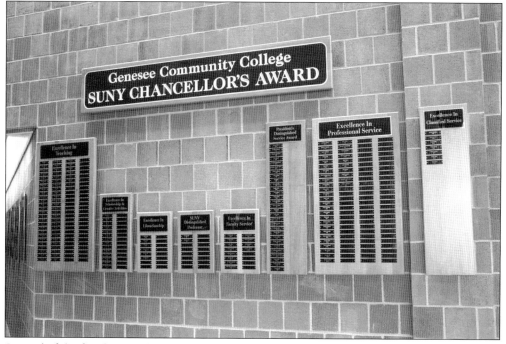

Several of the faculty members from this foundation group plus many others who came later have been recognized by the State University of New York for their outstanding contributions to the classroom. Today, the SUNY Chancellor's Awards recognize excellence not only in teaching, but also scholarship and creative activities, librarianship, faculty service, professional service, and distinguished professors.

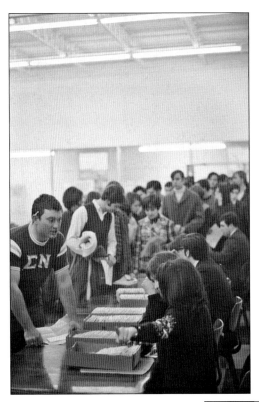

Student registration was an arduous task in the late 1960s. Students had to stand in lengthy lines to collect class cards that allowed them to register for the classes they wanted or at least for a class that was not already filled. Today, 50 years later, students can register online in the comfort of their homes and know immediately if they can secure the desired classes.

The early library, with 5,000 volumes, was an adequate beginning but only permitted a small area for individual students to meet and work together. Students often had to seek other locations. The students pictured here found a place at the entrance to the college just outside the library. The move to the new campus in 1972 dramatically increased the available library space.

Students who wanted to work in larger groups were especially challenged. This is in sharp contrast to the library today, where group study rooms are available along with open gathering areas. Many programs now require that students work together on projects in preparation for the more diverse and collaborative workplace of today.

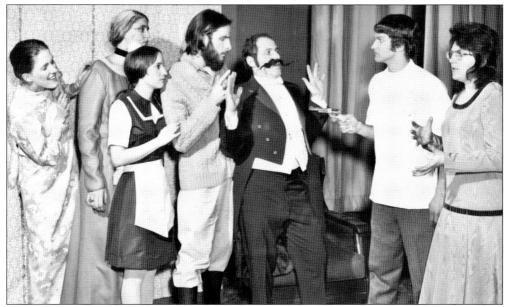

Cocurricular activities in the renovated building were limited, but Genesee County had several venues that allowed students multiple opportunities elsewhere. Here, students in the Forum Players, the GCC dramatics group, are shown rehearsing *Curse You, Jack Dalton*. Lacking space on campus, the play was presented at the 1971 Jaycee Home Show. Students and the public could see current movies as part of a cinema arts series shown at a theater on Main Street.

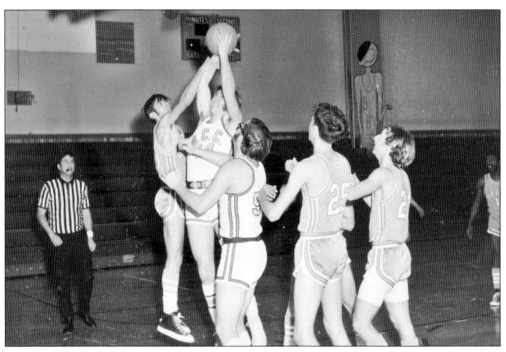

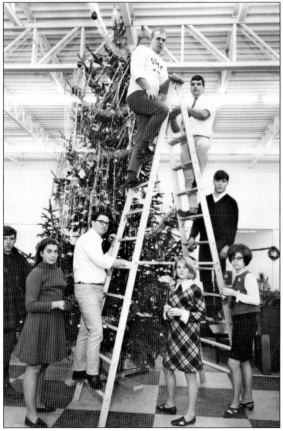

Sports teams are an integral component of the Genesee experience. Playing in a gymnasium at the YMCA, the basketball Cougars in 1968 competed against such teams as Fulton-Montgomery Community College and St. John Fisher. The men's basketball team has been highly successful over the years. The women's basketball team, which began in 1969, went undefeated in that first year. Today, Genesee has 11 competitive sports teams.

For the first holiday season at the college, the students erected and decorated a 16-foot tree in the lounge. Decorating the tree are, from left to right, Paul Tripi of Buffalo, Shirlie Sydoriak of Lancaster, John DeWitt of Pavilion, Sandra Stout of Perry, and Judy Loveland of Alexander; and, on the ladder from top to bottom, Daniel Clor of Batavia, Gary Call of Stafford, and Brian Lucca of Tonawanda.

The first graduates of Genesee Community College walked across the stage in June 1969. There were 78 graduates, most of whom planned to transfer to a four-year college. Within two more years, 37 of these graduates had their baccalaureate degrees. The first graduation speaker was William A. Setchel, an original trustee of the college. He initiated a long line of distinguished speakers including George McGovern, Barber Conable, George Plimpton, and Abby Wambach.

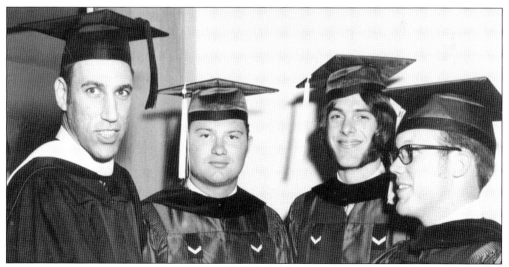

Academic dean Stuart Steiner, on the far left, congratulates, from left to right, 1969 graduates John H. DeWitt of Pavilion, recipient of the board of trustees award for leadership and contribution to the college, Thomas E. Puleo of Batavia, winner of the Edward A. Hammers Memorial Mathematics Award, and Robert G. Knickerbocker of Attica, who won the Citizens Committee and Faculty Award for the highest academic standing with a 3.75 average.

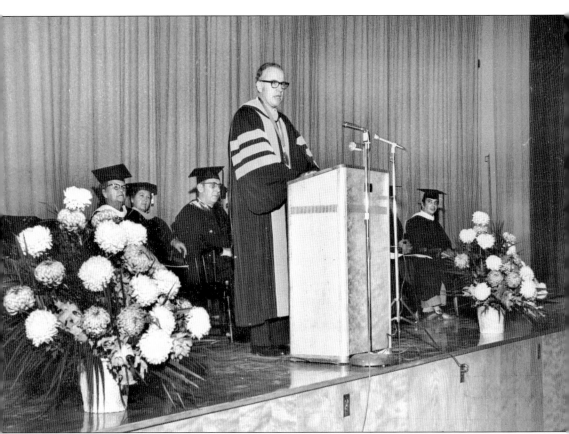

Dr. Cornelius Robbins became the college's second president in 1970. He was officially installed at an inauguration ceremony on October 27, 1970. Dr. Robbins served until 1975 and would oversee the college's 1972 move to its permanent campus northeast of Batavia. As described in the next chapter, with the new campus, the number of students and programs would increase substantially. By the fall of 1972, there would be 1,873 students enrolled at GCC.

Three

THE NEW BATAVIA CAMPUS 1972–1991

The campus on West Main Street Road, now County Building 2, was never intended to be more than a temporary location. There was no large space for major gatherings such as for graduation ceremonies. It lacked a gymnasium and playing fields. There was no theater. Office space was so limited that faculty members shared offices in groups of three or four. However, it was not a completely negative setting. One plus that early faculty members recall from those first few years was the absence of windows. The latter eliminated distractions when conducting classes.

The new campus provided an opportunity to design a complete set of facilities from scratch. The first step in building a permanent campus was, of course, to select an appropriate location. Several possibilities came under consideration, all within the vicinity of the city of Batavia. Ultimately, the decision-making process led to the current site, a 250-acre tract stretching south from the Thruway and situated immediately west of the Batavia-Stafford Town Line Road. This property was purchased for $117,891 in January 1969.

Access to the property required construction of a road running east-west between the Batavia-Stafford Town Line Road and the Bank Street Road. Initially named College Road, it was later renamed Assemblyman R. Stephen Hawley Drive in honor of Assemblyman Hawley.

A request for bids for the design of the new campus had been advertised previously. The winning bid was awarded to Perkins and Will Partnership of White Plains, New York. The general contractor for the construction of the new campus was John Luther and Sons of Rochester. Construction began soon after purchase of the site, and faculty and students moved into the new facilities in January 1972.

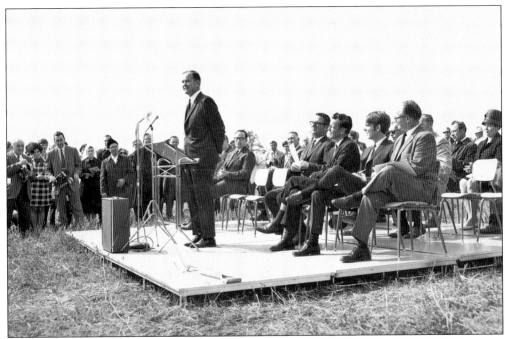

The start of construction was marked by a ground-breaking ceremony on September 26, 1969. A large crowd gathered at the College Road site on an early autumn afternoon as speakers shared their thoughts regarding the momentous nature of the occasion. In the picture above, the Honorable Barber Conable, congressional representative and an avid supporter of the college, addresses the audience. Forty years later, a technology building would be named in his honor. In the picture below, Trustee Almeta George inserts a ceremonial spade into the earth. Looking on are, from left to right, Conable, New York state assemblyman James L. Emery, college president Alfred O'Connell, and college trustee Anthony Zambito.

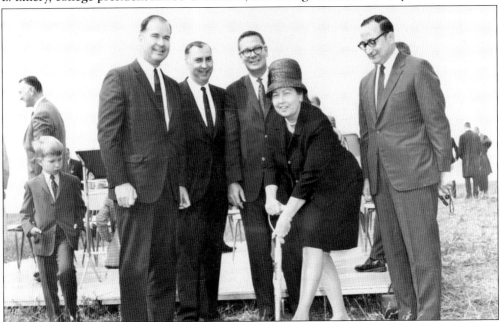

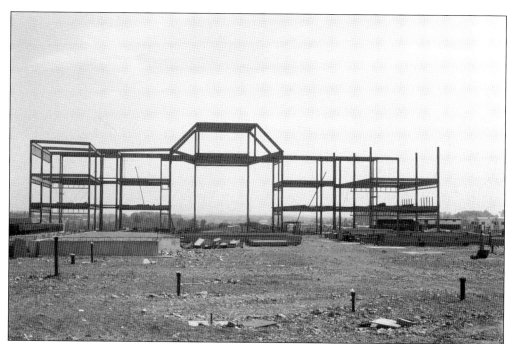

The 260,000 square feet of construction at a cost of $11.6 million was the most expensive undertaking in the county's 167-year history. In the picture above, the steel framework is just starting to be erected. At this early stage of construction, the countryside to the east is still visible through the girders—a countryside lying below the bluff on which the completed buildings will stand. In the picture below, the general shape of the buildings is revealed, one that features open common areas flanked on either side by three floors of offices, classrooms, and other spaces. Completion of the construction would require a little more than two years.

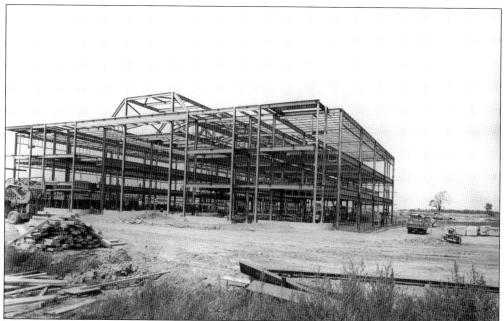

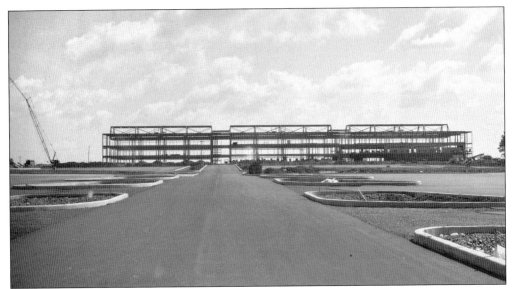

This view reveals an uncommon feature of the buildings that made up the campus complex. Rather than being freestanding structures, the five buildings were interconnected so that it would not be necessary to go outdoors when walking from one building to another. Over the years, especially during Western New York winters, thousands of students came to appreciate this thoughtful design.

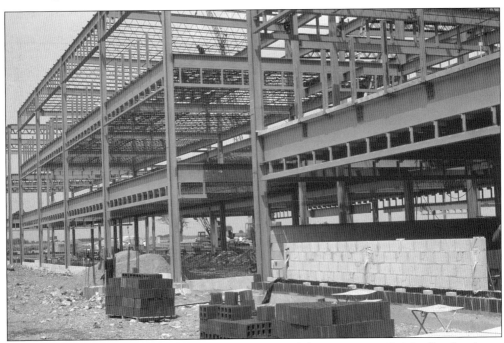

In the center of this picture is the location of one of the entrances. Originally, the doors had hinges on the edges arranged in the conventional manner. However, the force of wind blowing through the parking lot often proved so formidable that the doors were replaced with a design featuring hinges set closer to the center of the doors so that less muscle was required to open them.

In this view, construction materials can be seen atop a roof. The fierce winds that prompted the redesign of the doors as described in the preceding caption were also the undoing of the original roof. Before construction had been completed, one particularly violent windstorm stripped away this first roof, thereby requiring a redesign and second start.

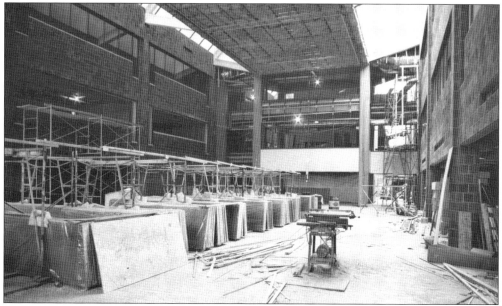

This interior view clearly reveals one of the common areas flanked on either side by classrooms and offices. This space, looking north, would become the cafeteria. The campus buildings were constructed without basements, a design dictated by the bedrock immediately below grade. This same bedrock also influenced the construction of the pool, a matter to be discussed shortly.

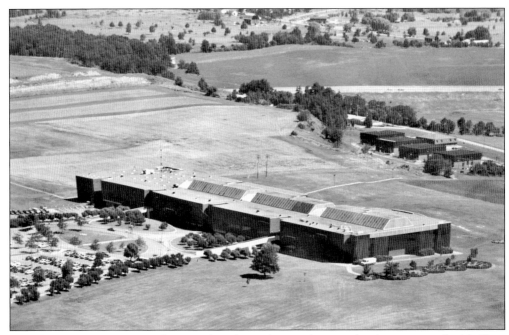

The above picture, an aerial view taken from the southwest, clearly portrays the bluff on which the campus buildings sit. The highway in the distance is the New York State Thruway. Visible on the south end of the first building are four of the multiple wooden features intended by the architects to simulate silos, in keeping with the rural nature of the county. Also visible are two concrete ramps leading to the second floors. The picture below reveals the profiles of the ramps. Sometimes tricky to navigate in icy weather, these structures were later removed when additions were made to the original five buildings.

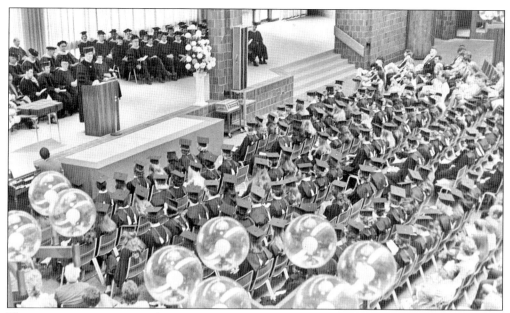

The remaining pictures in this chapter all deal with courses, programs, and activities made possible by the new campus that were difficult or impossible with the temporary facility. A limitation of the temporary campus was the absence of a common area big enough for large gatherings. As shown in this picture, that obviously changed. Pictured here is the first graduation ceremony on the new campus, an event held in the forum, a space later named the William W. Stuart Forum in recognition of his efforts in support of GCC.

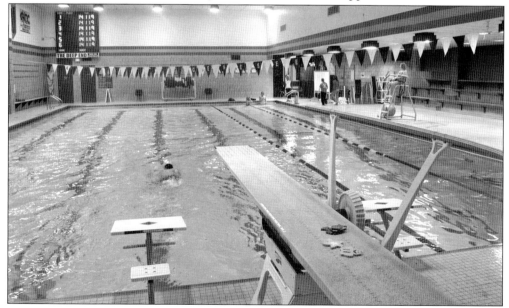

Prior to construction of the new campus, the Batavia YMCA provided the only year-round access to a public pool. This sizable pool on the new Batavia campus provided recreational and instructional opportunities heretofore unavailable in the community. The bedrock below led to the construction of the pool on the second floor; and that in turn permitted a window on the first floor by which swimmers can be viewed.

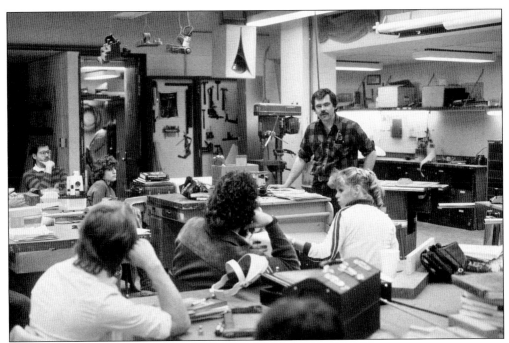

An instructional program made possible by the new facilities was industrial modelmaking. Shown above is a class being conducted by Edward Stringham. Stringham also operated his own modelmaking company. Students learned to construct models made of steel, plastic, wood, and other materials. This prepared them for employment in companies such as Kodak and Xerox, where models were used in the course of product design and for advertising layouts. In the picture below, a student is working at a wood lathe. GCC was one of only a few colleges to offer industrial modelmaking. The program is no longer a part of the curriculum.

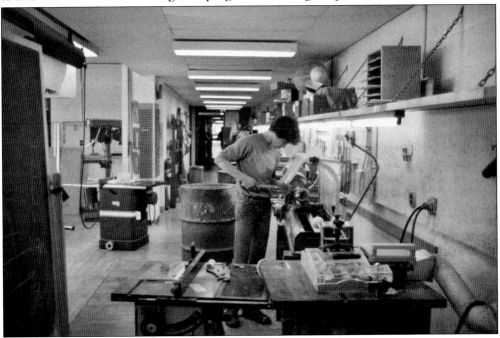

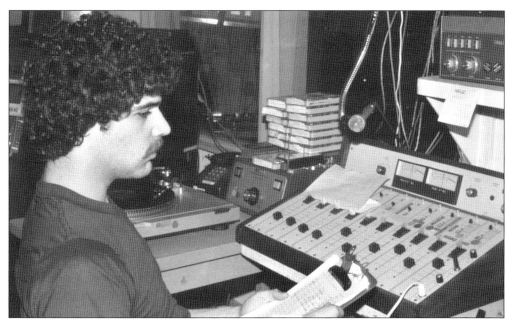

These two pictures illustrate yet another instructional program made possible by the facilities of the new campus: radio broadcasting. In July 1979, WGCC began broadcasting on campus. There was no over-the-air capability yet, and one's radio had to be plugged into an electrical outlet to receive the signal. The picture above shows the early studio, and the picture below the more recent layout. On November 13, 1985, the station received a license to broadcast over the air on an FM frequency of 90.7. The signal has a range of approximately 25 miles, extending a little more to the east than to the west. The student disc jockeys mainly play music intended to cater to fellow students.

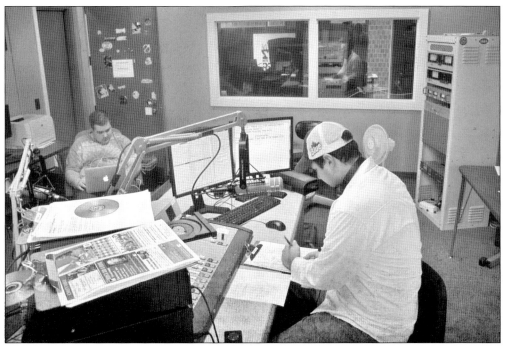

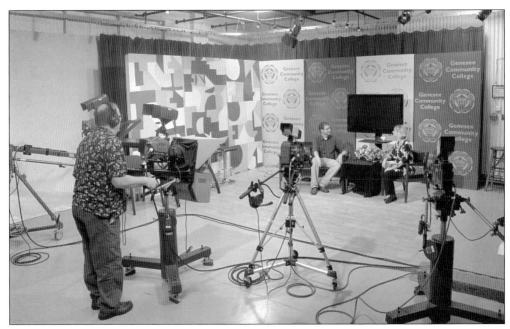

On the new campus, it also became possible to create visual media for instructional use. The above picture shows the videotaping of an interview in the studio, while the one below shows the control room. During the first few years, each classroom was equipped with a monitor connected to the media center. Ordinarily, when instructors wished to show a movie or video, it had been necessary to have projection equipment taken to the classroom. With the classroom monitors, an instructor needed only to call down to the media center via an intercom and the film or video was transmitted over circuitry to the monitors. The eventual development of "smart classrooms" rendered such technology obsolete.

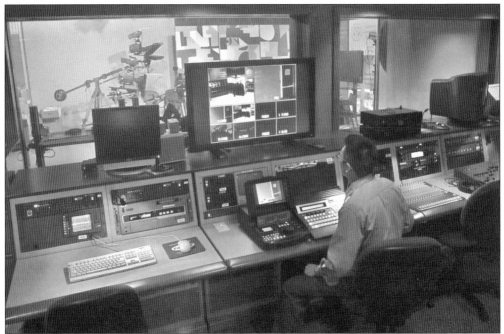

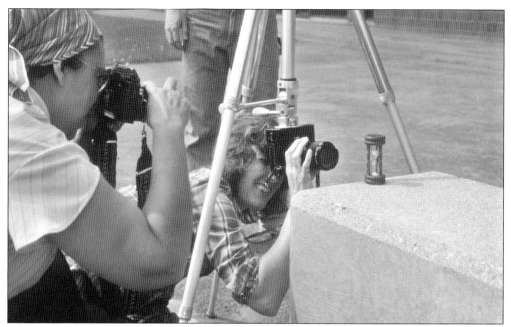

With the new campus, access to a darkroom was available for the first time, and full-fledged photography courses became available. In the 1970s, digital photography was not yet possible, so students learned to develop negatives and print photographs from them. In the picture above, students are shown using 35-millimeter film cameras to make pictures of an hourglass. The picture below shows the resulting image after processing. The alert reader may note, in the lower image, what appears to be a cell phone in the jeans pocket of the student sitting on the wall. However, it is certainly only a notebook, since mobile devices were still years into the future.

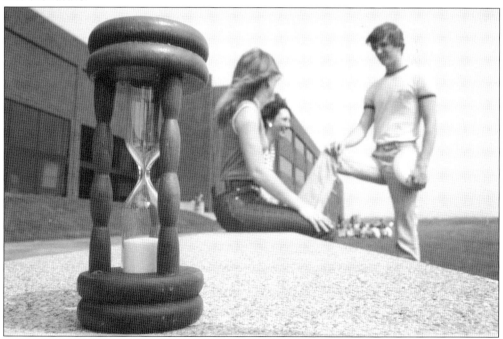

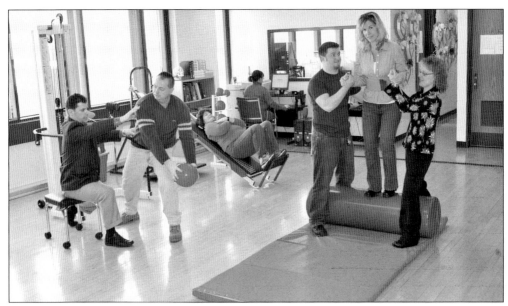

One final illustration of an area of study made possible by the new campus is the physical therapist assistant (PTA) program. Duties of a PTA include training patients in exercises that help people with injuries to relieve their pain as well as heal and regain function so as to lead more normal, independent lives. Physical therapist assistants work at many different health-care facilities, such as sports-care clinics, nursing homes, hospitals, and rehabilitation centers. Above, instructor Peggy Kerr (right) works with students on equipment designed to improve dynamic balancing skills. Below, she demonstrates equipment intended to normalize muscle tone.

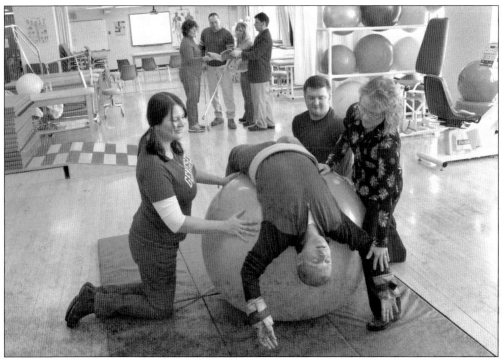

Four

EXPANSION OF THE BATAVIA CAMPUS 1991–2014

The expansion of the Batavia campus began with the opening of the Genesee Center for the Arts in 1991. This created the possibility of offering students many opportunities to increase their knowledge and experience in the fine arts. The addition of the 328-seat theater enhanced the college's ability to attract guest performers and present student performances by the Forum Players, the student theater group. In the years since 1991, the Arts Center has hosted a wide range of cultural events, expanding the knowledge and experience of students and community members.

The Conable Technology Building was named for Barber and Charlotte Conable, local supporters of the college who had each made significant contributions to the world well beyond Genesee County. Its opening in 2000 established GCC as a leader in technological innovation in instruction and workforce development. Included with this building initiative was a complete renovation of the Alfred C. O'Connell Library that involved removing a second floor for greater accessibility and adding a number of student-facing computers, thus moving the library into the technological age. Also included at this time was an expansion and remake of the Child Care Center to better serve the large number of students who are parents of small children.

The construction of the new student union occurred in 2005, greatly expanding the space available for student activities, learning, and relaxation. The union is dedicated to Wolcott J. Humphrey III, a strong proponent of the college who was chairman of the Genesee Community College board of trustees at the time of his death in 2001.

Additional developments in the last few years have included the moving of the nursing program to the Dr. Bruce A. Holm Upstate MedTech Centre across Hawley Drive from the campus. Additions have also been made in the last few years to College Village, the student resident complex owned by the Genesee Community College Foundation.

The last 25 years have seen a tremendous amount of expansion, which continues to meet the growing needs of students and the community. In the next few years, two additional buildings are planned that will continue a commitment, expressed by the college's motto, to go "beyond expectations."

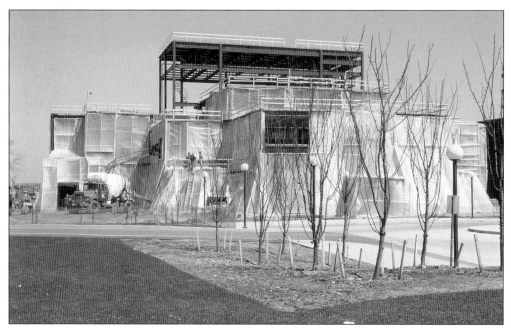

In the late 1980s, it was clear that the college and the community needed a new place for people to study and appreciate the creative arts. There was no longer space in the main building for the development of a comprehensive program. The new Arts Center building was designed to provide space for academic programs and included a 328-seat theater for student productions and community involvement. Construction on the 40,776-square-foot Arts Center concluded with its opening in 1991. The center, in order to be attached to a main building, required the removal of an exterior ramp that provided access to the second floor of that building. Many people missed the aesthetics and functionality of the ramp while still being excited about the new center.

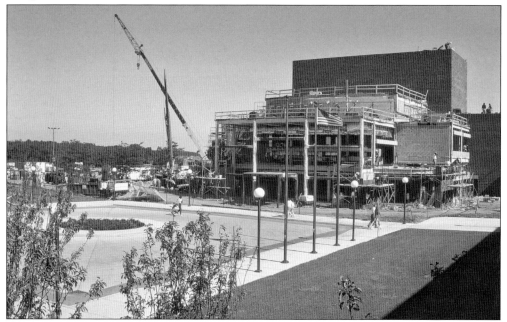

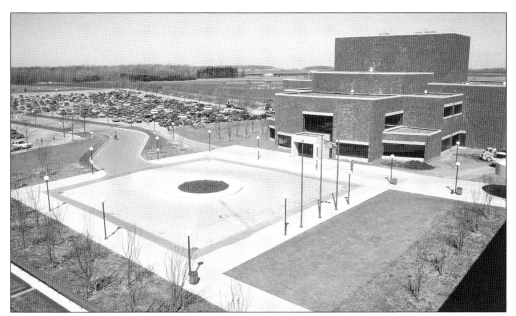

The main access to the theater was placed on the college's entrance plaza. This allowed attendees to easily walk the short distance from the parking lot and enter the lobby that runs the length of the front of the building. The back of the building faced the loading area, thus facilitating entry of large equipment for instruction and productions.

The hallway in this picture connects the Arts Center with the main campus. The goal of the original construction was to contain all the buildings in one space so people would not need to go outside to move across campus. This hallway allowed for that goal to be maintained. It also permitted special receptions and dinners to be held in the main buildings with easy access to the theater.

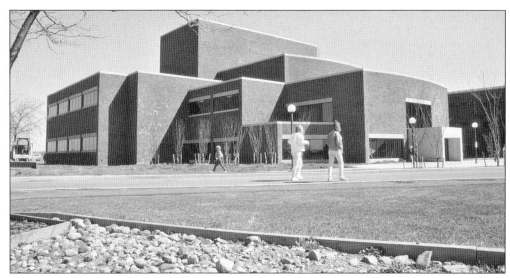

This side of the Arts Center has two rows of windows and houses classrooms and faculty offices. The music room, ceramics studio, drawing and painting studio, dance studio, and costume shop are on the second floor. In addition to the theater, the first floor houses the digital arts program, the technical theater program, and class space.

During the college's 25th anniversary year in 1992, the board of trustees surprised Pres. Stuart Steiner by naming the new theater in his honor. He had been president since 1975 and was recognized for his innovation and leadership at the college and for his national designation as a "transformational" community college leader.

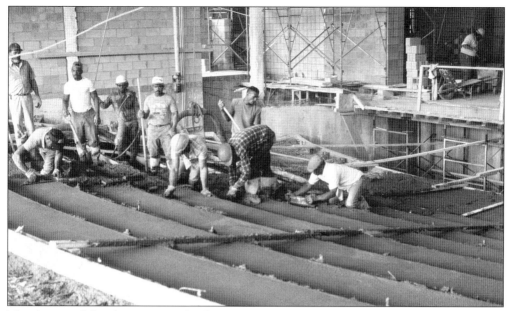

The design of the theater provides for comfortable seating that allows a clear view of the stage from any one of the 328 seats. Students and staff have won many theater awards, such as the prestigious Theatre Association of New York State (TANYS) award for Best Long Play in New York State. The award was for a production of the play *for colored girls who have considered suicide/when the rainbow is enuf.*

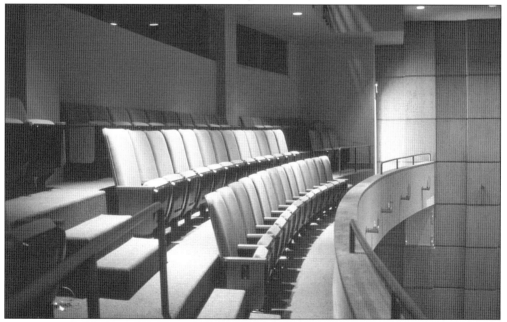

The balcony of the theater allows a panoramic view of the stage. The balcony is especially needed for sold-out productions such as the annual Children's Theater, developed by Prof. Norm Gayford. The production runs for one week and then tours regional schools and communities for another two weeks. The Arts Center hosts professional acts that are also often sold out, so the extra balcony seats again are welcome.

The theater lobby includes a spiral staircase leading to the balcony. The windows surround the entire front of the lobby, creating an attractive space for theater audiences and receptions. The finished lobby has an ongoing exhibit of artwork created by students and community members. For example, a local congressman has hosted a juried art show of work submitted by children from all over Western New York. In addition, when students return from a summer semester abroad program, the experience is highlighted. Each year, artists are asked to submit work to be selected for presentation in the lobby.

The box office is located in the lobby. Each year, plays are presented by students, faculty, and community members. The play *In the Blood* won the Excellence in Directing Award for director of fine and performing arts Maryanne Arena; an award for choreography; and an award for best stage design that was presented to theater technology program faculty member Ed Hallborg.

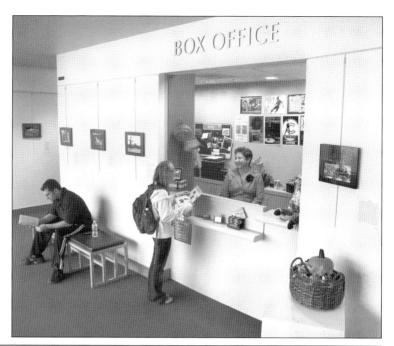

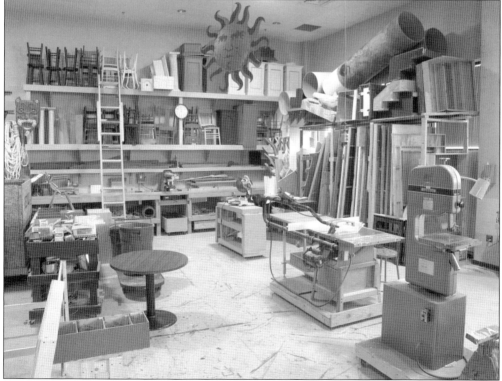

The scene shop is part of the award-winning theater technology program that provides hands-on experience in the specialized technical and artistic skills required to execute contemporary theater productions. Students learn how to create a stage that brings the production to life and transports the audience to another time and place.

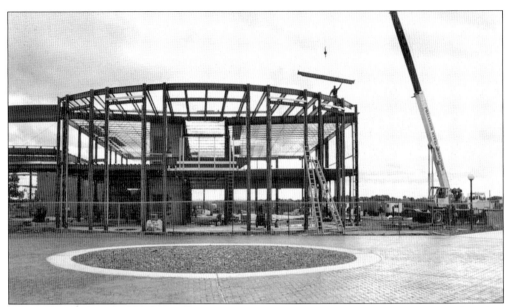

Construction of the 43,000-square-foot Conable Technology Building was completed in 2000. The building houses distributed learning and the BEST (Business and Employee Skills Training) Center on the first floor. The second floor is devoted to teaching classrooms equipped with a computer for each student, a large open computer lab, and a room with the technology for point-to-point real-time communication.

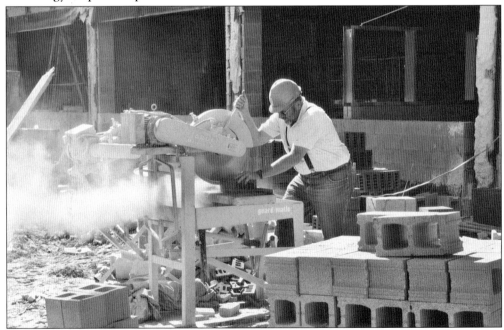

Many skilled tradespeople were required to take the building from drawings to completion. The college employed JMZ Architects and Planners, PC, from Glens Falls, New York, for the design of the Conable Building. Subsequently, JMZ has been the designer for all of Genesee's other additions to the main campus, including the newest buildings, set for completion in 2017.

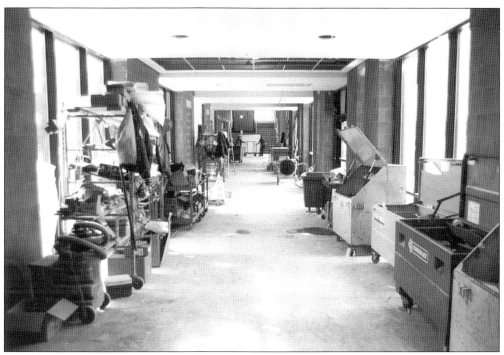

Once the external construction of the Conable Building was complete, it was time to work inside. This view is looking west down the corridor connecting the building to the main campus, a feature ensuring that the campus remains under one roof. The stairs at the end access the second floor of the building. The BEST Center is at the foot of the stairs to the left.

Once completed, the Conable Technology Building reaffirmed the college's continuing commitment to provide state-of-the-art technology teaching and learning opportunities. The building also complemented the Arts Center, since they face one another across the entrance plaza. The plaza is a gathering place for students when the weather permits.

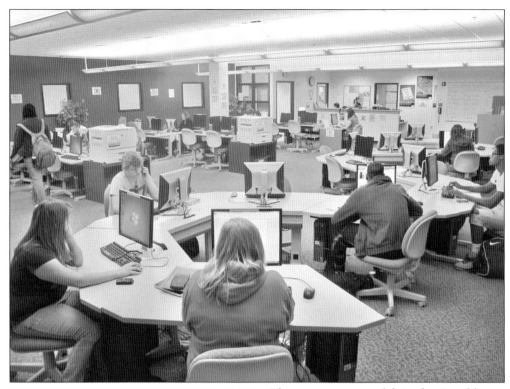

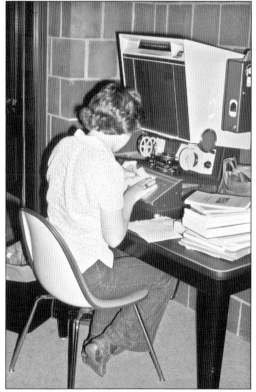

The open computer lab in the Conable Building affords students with 58 workstations arranged to provide either privacy or collaboration. Genesee has had a contract for computer services with Ellucian since 1979. The goals of the initial contract include ease of access, expanded innovation, increased support, and improved instruction. These fundamental goals remain today, ensuring that students are adequately prepared for the work world of the 21st century.

The library underwent a major renovation when the Conable Building was constructed. At that time, students were still using microfilm, as pictured here. Today, the library is equipped with 49 student-facing PCs plus 24 laptops for use in the library. The library classroom, dedicated to Lynn Browne, a longtime advocate of the college, has 26 computers. The holdings total 91,639 items, including CDs, audiobooks, and other media in addition to traditional books.

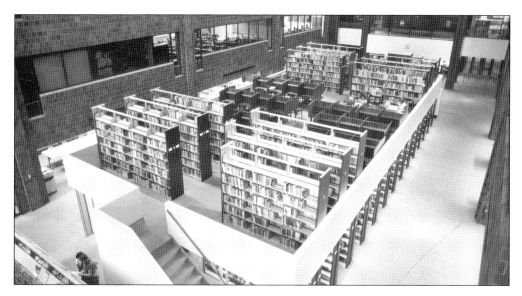

The renovation dramatically changed the layout and functionality of the Alfred C. O'Connell Library. As seen in the picture above, the library had a second tier of books and individual study spaces. The second tier was only accessible by the staircase in the picture. The new library, pictured below, has open spaces with comfortable seating, worktables if students choose to work together, and computer stations. There are small rooms for students to work on projects without disturbing others. The information kiosk is staffed so students can easily access needed information and is separate from the main desk, where materials are checked out. The library has become a very different and student-friendly place. Community members are also invited to use the full range of these facilities.

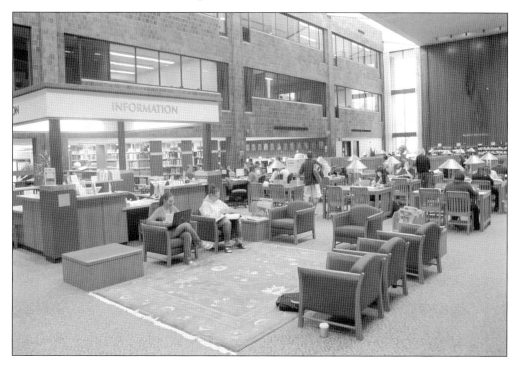

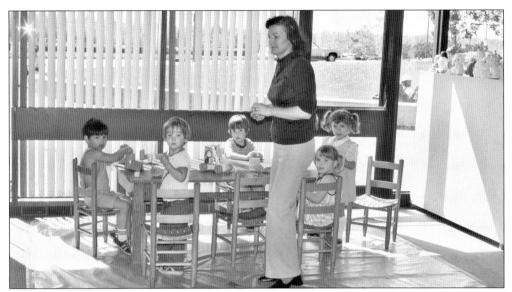

A third component of the most extensive renovation since the campus opened in 1972 was the Child Care Center. Genesee recognized the need for a center to assist students with children as early as the mid-1970s. A small center was opened and functioned adequately, but it became increasingly clear that a larger, brighter, and more interactive space was needed. The new center opened with places for 53 children.

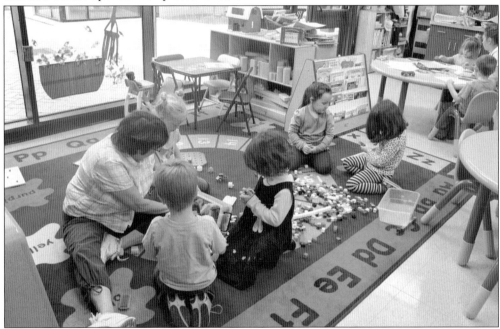

In the new Child Care Center, children are able to engage in fun learning activities designed to ensure that they are fully prepared for the next step in their development. Age-appropriate activities provide opportunities to interact with other children. Many interns from the human services and teacher education transfer programs fulfill their placement requirements there. Staff may also use the center for their children, provided the needs of students have been met first.

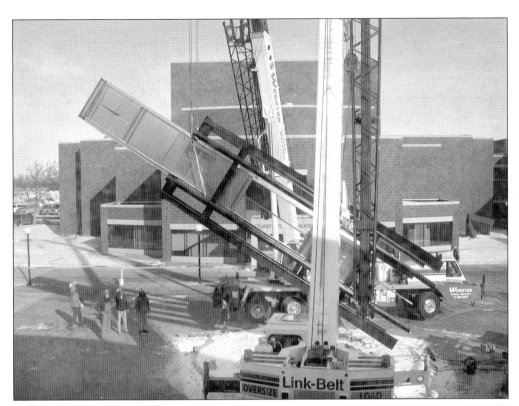

In June 2000, the board of trustees gave formal approval for the construction of a clock tower funded by the GCC Foundation. The initial site work for the tower was completed during construction of the Conable Technology Building, when the architects recommended that the college add a clock tower in the plaza. The raising of the 34-foot-high metallic tower took place in January 2001. Once erected, the clock tower was not met with universal approval. Some members of the college community did not feel that the tower was the "signature" piece originally desired. Others felt the design did not fit into the appearance of the other buildings. Some people objected to the cost. It was suggested that ivy be added to grow around the posts as well as plantings at the base.

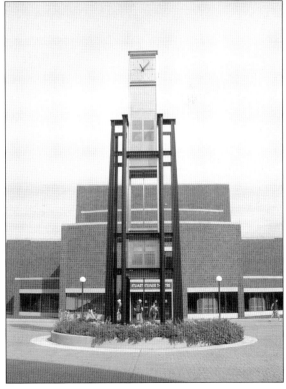

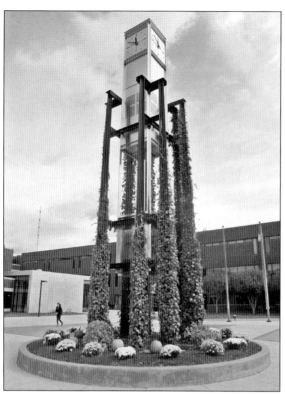

In recent years, as the ivy has grown, the controversy over the clock tower has abated. The clock has a digital chime that announces the quarter hour as well as the hour, and it is equipped to play different kinds of music for various occasions. It is a convenient meeting place and anchors the entry plaza.

In 2006, the Wolcott J. Humphrey III Student Union was dedicated. Humphrey was an avid supporter of the college and was chairman of the Genesee Community College Board of Trustees at the time of his untimely death in 2001 at age 50. There had been limited dedicated space for students in the main buildings, so the 10,500-square-foot union was eagerly anticipated.

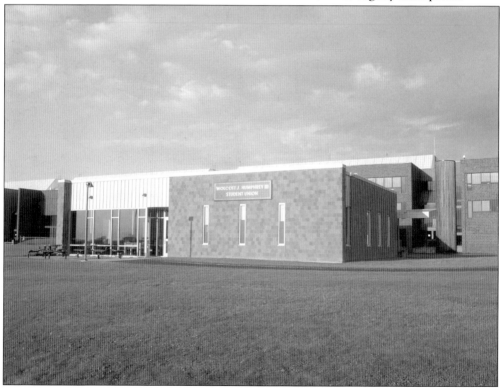

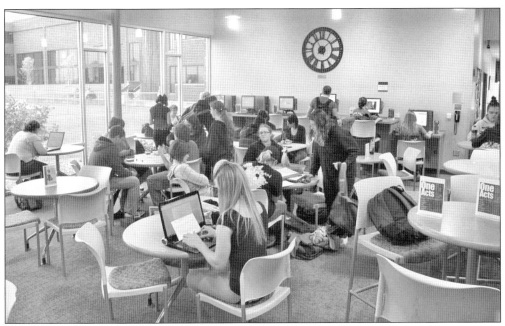

The student union includes a large meeting area for students to work or relax. There are computer workstations along one wall, and many students choose to work in this open area with its large windows to the outside. The offices of the student activities staff are nearby, as is the dedicated space for the Veterans Lounge. Adjacent to the open area is another lounge area complete with a small fireplace and television. This area is well used by students and provides a place for "fireside chats" sponsored by the Student Activities Office or other organizations on campus. Topics for the chats range from transferring to a four-year college to dating and roommate conflicts.

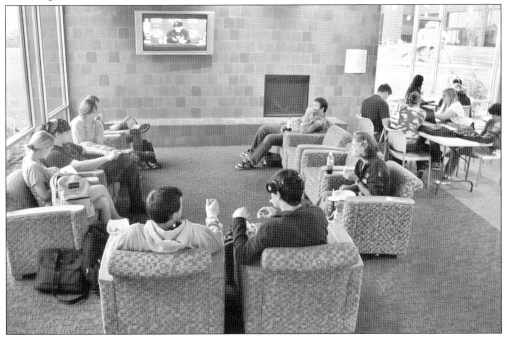

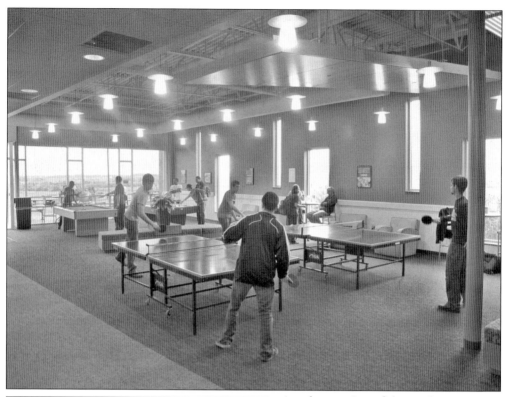

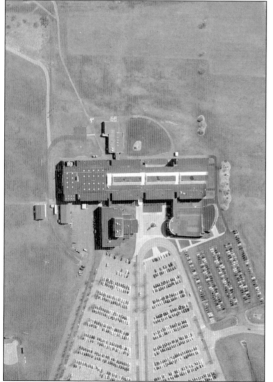

Another section of the student union houses Ping-Pong and pool tables. Pres. Stuart Steiner was a skilled Ping-Pong player and could frequently be found playing with students who were in the union. There were tournaments for any students who wanted to challenge Dr. Steiner. The president won more than he lost.

An aerial view of Genesee's main campus documents the impact of these building projects. The Arts Center is on the left, and the Conable Building, with added parking, is on the right. The clock tower is in the center of the entry plaza, and the student union is on the other side of the main buildings. A childcare play area is to the right of the union.

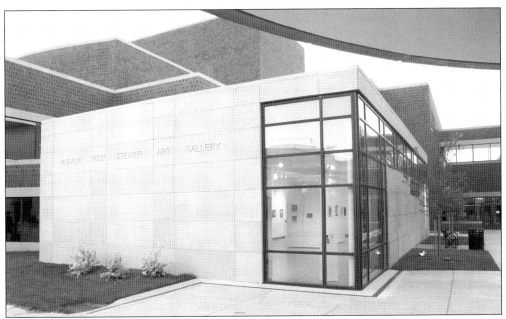

In 2011, the 1,400-square-foot Rosalie "Roz" Steiner Art Gallery was built. The gallery is named in honor of President Steiner's wife. She was a continuous advocate for the college and hosted many receptions at the Steiner home. The gallery is a lasting tribute to her memory and celebrates her life. The art gallery is attached to the Arts Center with entry through the Stuart Steiner Theatre lobby. It has created a unique space with 1,700 linear feet of wall space in order to show student work as well as the work of professional artists. Receptions are often held to introduce new work, and the community is invited to participate.

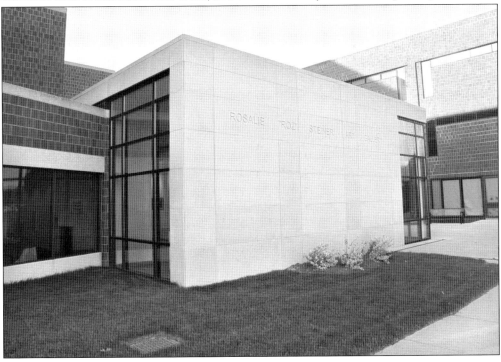

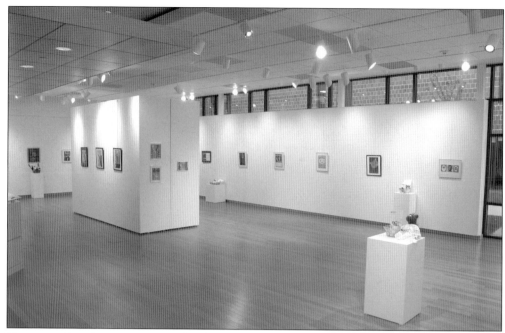

The art gallery hosts a variety of exhibits. In 2015, there were exhibits of abstract painter Jonathan Langfield, viewings of the post-graffiti style of Nate Hodge, and works from the Gerald Mead Collection ranging from the 1800s to the present day. WXXI in Rochester, the public television station, featured the Hodge works in its "Art in Focus" offering.

This sculpture, designed by Henry Wilhelmi of Syracuse, sits at the west end of the Arts Center. It was originally commissioned by the City of Batavia to celebrate the spirit of the city when Genesee Country Mall was erected during urban renewal. It was not well received. The sculpture was subsequently donated to GCC after the construction of the Arts Center. It continues to receive mixed reviews.

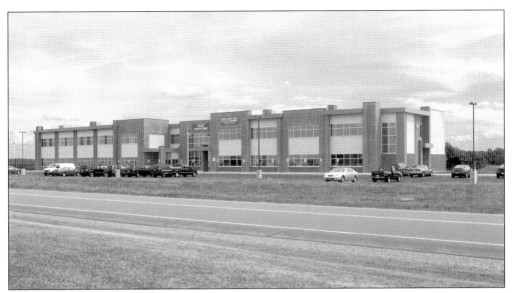

The dedication of the Dr. Bruce A. Holm Upstate MedTech Centre, owned by the Genesee County Economic Development Center, occurred in 2010. The first floor is devoted to private entities, while the second floor houses space leased by Genesee Community College for its expanded School of Nursing. This is the first time an entire program has been located off the main campus.

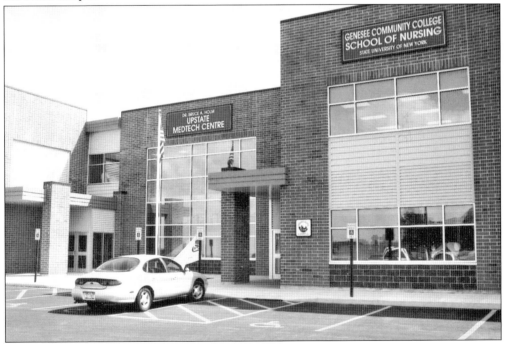

The GCC School of Nursing now has state-of-the art equipment that enhances the preparation of future nurses. For example, METIman, a high-fidelity patient simulator, can be programmed to respond with voices that mimic what a living patient would say. Students complete several hundred hours of clinical rotations in area health facilities. Nursing is the second-largest program at GCC.

Nursing classes began at the MedTech site in the fall semester of 2010. There was little time to make the move, and it required all hands on deck to succeed. Kathy Palumbo (left), director of nursing, and Bethany Gabriele, the daughter of the lab coordinator, are seen here moving the patient simulators. The nursing program had outgrown the main campus, and the new building provided the required space and equipment.

The three high-fidelity and 24 medium-fidelity patient simulators create real-life experiences for the students. Here a student works on a "patient" under the watchful eye of instructor Elise Muoio. Another student records the session so the student can later review her technique. Note the students are in GCC nursing program uniforms, a requirement for working in the lab.

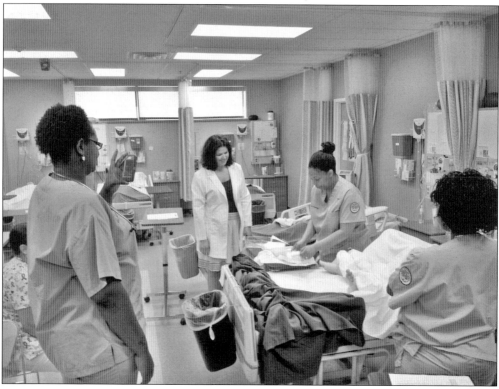

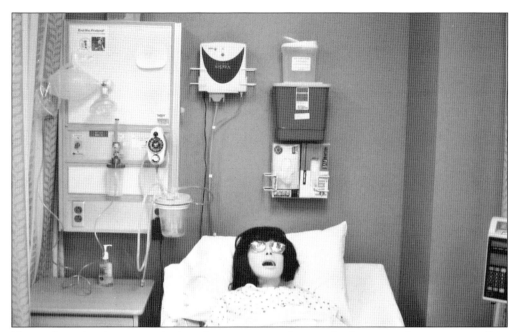

The patient simulators are designed to expose students to both men and women as well as different ages and ethnicities. The station is equipped with materials that would be available in a hospital setting. All of this ensures that students are ready for the state boards, where the GCC passing rate has been consistently above the state and national averages. Just since 2010, over 600 students have graduated from the nursing program.

The nursing laboratories mirror a hospital setting where multiple patients may need attention at the same time. The laboratories have especially been busy since 2008, with the addition of a January start-time and a licensed practical nurse–to–registered nurse advanced placement program. Today, former students are registered nurses working not only in Western New York facilities but in other locations as well. Many of the nurses at the local hospital in Batavia are GCC graduates.

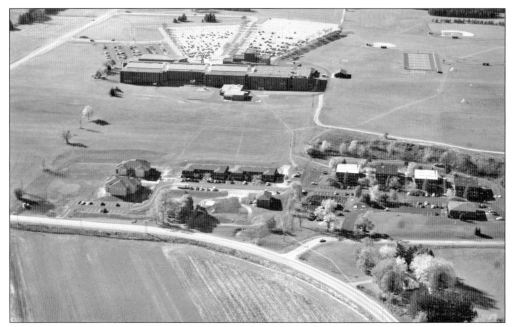

In 2001, the Genesee Community College Foundation, a charitable organization providing support to the college and its students, purchased the privately owned College Meadows housing complex, which was located at the foot of the hill to the east of the main campus. When purchased, there were seven buildings that then housed 300 individuals, a mix of community residents and GCC students. The name was subsequently changed to College Village.

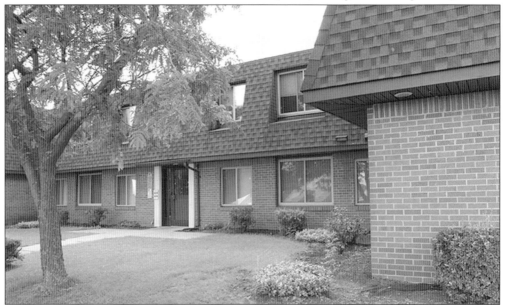

The original seven buildings needed extensive improvements. The foundation expended more than $1.5 million to upgrade the buildings with sprinkler systems, new windows, energy-efficient heating systems, and high-speed Internet. In 2007, two additional buildings were added to the south of the existing ones. This increased by 64 the number of students who could live at College Village.

Beech, Birch, Cedar, Hickory, Maple, Oak, and Pine are the seven original buildings. They are at the northern end of the complex as it stands today. There is an uphill walkway that connects College Village with the campus. The village has a staff of 20, including resident advisors who live on-site and attend GCC. The staff also includes 24-hour security to ensure the safety of the student residents.

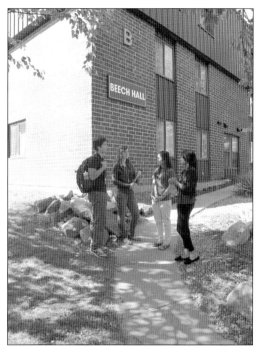

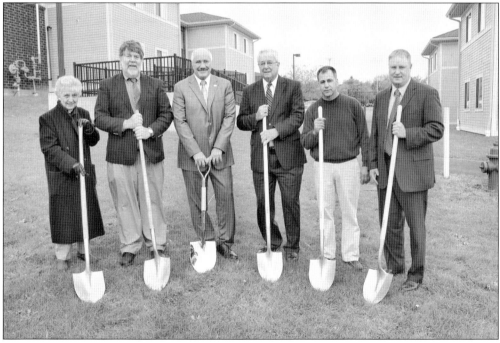

Ground breaking for the last additions, Hemlock and Lilac Halls, occurred in 2014. Pictured from left to right are Laura Bohm, GCC Board of Trustees member; Norbert Fuest, GCC Foundation Housing Services; Dr. James Sunser, GCC president; Robert Boyce, GCC Foundation president; Joseph Condidorio, chief executive officer of Whitney East, building contractor; and Richard Henry, GCC Foundation board member. Once completed, these additions brought the total number of students living at College Village to 455 in 11 buildings.

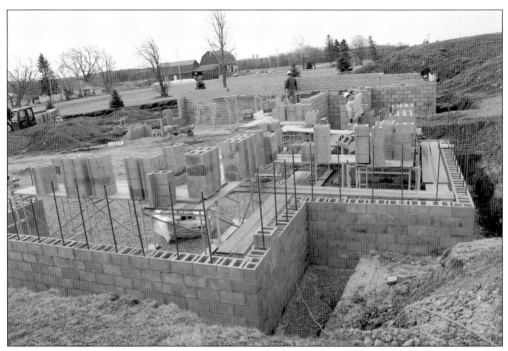

As construction was completed, the need for programming and resources at College Village became even more important. As part of the 2007 building project, a central building, the Village Hall, was added to house staff and to provide a small gathering space. In 2014, College Village opened the Root, a large multipurpose area for social and educational activities, including selected academic classes. One of the difficulties of a rural campus is that students without transportation are very restricted. In 2015, the merchants in Batavia joined with College Village to host a public forum to explore ways students can take advantage of resources in downtown Batavia. As a result, transportation will now be provided on weekends. College Village allows students from beyond the immediate area to take advantage of the unique programs at Genesee Community College.

Five

CURRICULA AND
COCURRICULAR ACTIVITIES

The college offers over 60 degree programs and many one-year certificates to meet the needs of students. Many programs that began with the opening of the college in 1967 are still offered but have been updated and renamed. Police science, now criminal justice, and secretarial science, now administrative assistant, are two illustrations. Some new programs are the product of technologies that did not exist in 1967. Computerized drafting and polysomnography are two such examples. Many older programs have incorporated new technology in order to more adequately prepare students.

Genesee has always responded to the needs of people in the GLOW region (Genesee, Livingston, Orleans, and Wyoming Counties) when developing new programs or sustaining current programs. The new food processing technology program is such an example. New food processing plants moved into the region and needed skilled employees. This degree helps provide those employees.

While such career programs prepare students for the workforce, GCC has never lost its commitment to prepare students for transfer to a baccalaureate institution. In particular, the teacher education transfer program prepares students for transfer to the many SUNY institutions in the area as well as private colleges that prepare teachers. The largest program at the college remains the general studies program, which is designed for transfer students.

Genesee Community College has very strong sports programs that draw participants from well outside its service area, even from other nations. This has been especially true of the basketball and soccer programs. In addition to basketball, GCC athletes participate on baseball teams, engage in swimming competitions, run in cross-country events, play volleyball, compete in lacrosse, play soccer, and participate in golf tournaments. Over the last three decades especially, GCC has been a competitor in innumerable regional, district, and national tournaments involving several different sports. The lacrosse team won the National Junior College Athletic Association National Championship in 2016. Graduates have gone on to join teams at four-year institutions and some have become professional athletes. In December 2004, Genesee Community College was named "college of the month" by the National Junior College Athletic Association.

The criminal justice program began in 1969 as the police science program with 90 students. By 1972, there were 300 students, many assisted by federal funding for law enforcement and corrections personnel. Today, the program has concentrations in policing, homeland security/emergency management, corrections counseling, and forensics. In this picture, program coordinator Barry Garigen helps a student presenting to the class.

In this forensics class, instructor Karen Wicka is assisting students using a rape kit to determine if the fabric from a crime scene matches clothing the apprehended suspect was wearing. A plaster cast of a footprint is also evident in the picture. These hands-on experiences prepare students to conduct a criminal investigation that could be used in court.

A unique program that provides students with real-life experiences is the Student Safety Patrol. Students are chosen to work with the college's campus safety officers to monitor activities on campus and to assist anyone who needs attention. Here, officers Brenda Case and Eric Anderson instruct students in what their responsibilities will be for the day.

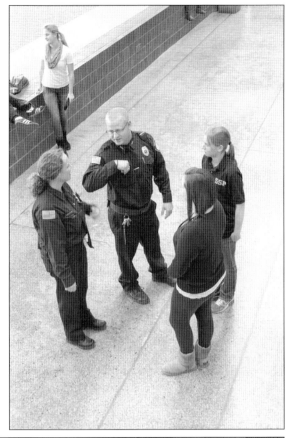

Students complete a 120-hour semester internship within a criminal justice agency. In this picture, Genesee County sheriff's deputy Brad Mazur demonstrates to a student the proper procedure for checking a driver's credentials. The college has maintained an excellent working relationship with the local law enforcement agencies, and many graduates are now working in the area.

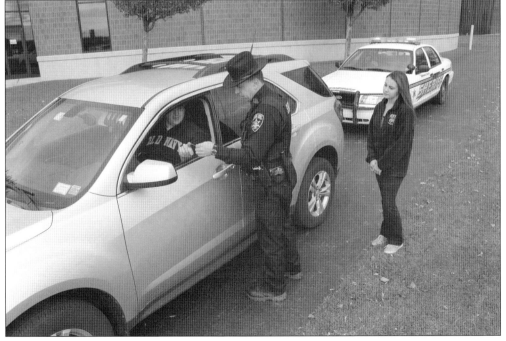

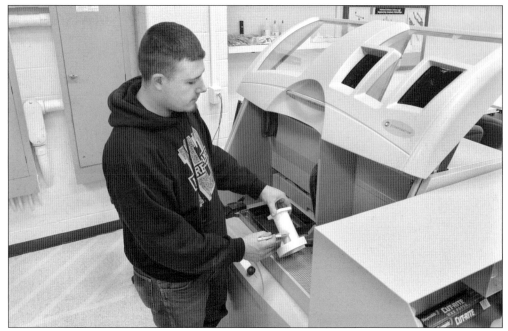

The computerized drafting and design program at GCC prepares students for careers where they will communicate ideas and instructions to others for the fabrication of products. State-of-the-art technology is crucial. In this picture, a student has just completed working on a product using the 3-D printer.

Computer-assisted drafting (CAD) software is essential to the field. In this picture, a student reviews the various designs that are possible when undertaking home construction. Students still complete two courses in manual drafting to be able to understand the fundamental aspects of the discipline, thereby providing an excellent example of merging traditional techniques with today's expanding technology.

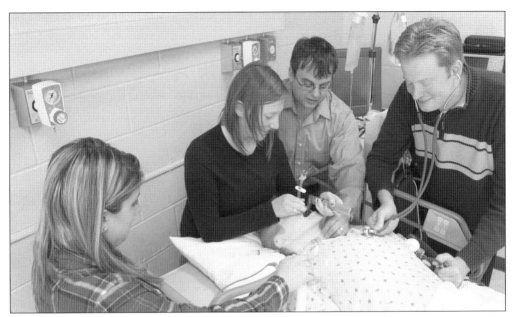

The respiratory care program is one of several programs within the health-care area. The program prepares students to be respiratory therapist assistants who use a variety of sophisticated equipment and techniques to measure how a patient's lungs and circulatory systems are working. Here, students check those areas under the guidance of instructor Josh Escudero.

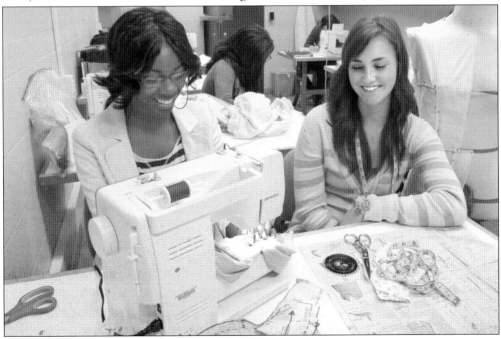

GCC has had a fashion merchandising program for 35 years. In 2009, a degree program in fashion design was added to the offerings, enabling a student's passion for fashion to be expressed in the design of commercial fashions as well as the management of fashion development products. In this picture, students Candice Cooper (left) and Natalie Brown are involved in working with materials to create a garment.

GCC has many certificate programs that typically take one year to complete and prepare students for specific careers or specialties. In the picture above, James Bucki, director of information technology, is assisting students in the computer repair certificate program. In the picture below, a student works in the laboratory to repair a computer. The information technology area has degrees in computer information systems, computer support and operations, computer systems and network technology, and web design, along with another certificate in help desk support. Successful students easily find employment in the GLOW region as well as regional and national locations.

Teacher education transfer was one of the first such programs offered at a community college. It prepares students to transfer to a baccalaureate institution. Students must work directly with children in an educational setting so that students can learn whether the career is the best one for them and what instructional level is best suited to their skills and abilities. In the picture above, Christine Belongia, associate professor in the program, works with students to help them understand different reading levels. In the picture below, a student works with a young boy with recognition and classification of shapes and other figures.

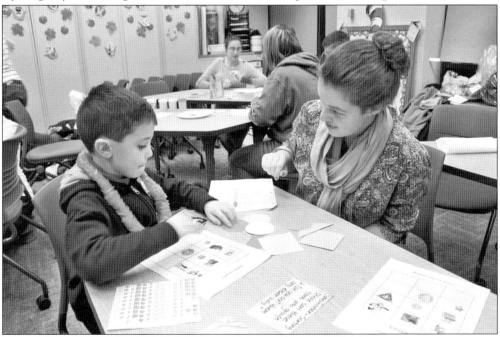

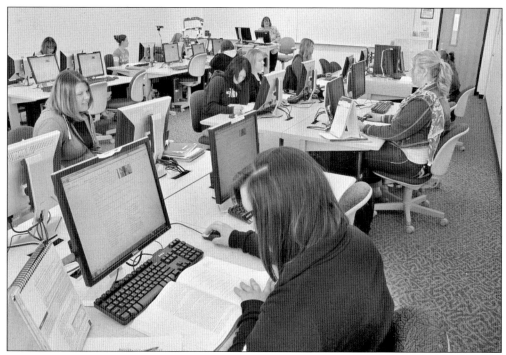

Secretarial science was one of the first eight programs at the college. Manual typewriters have given way to advanced technology that supports an administrative assistant degree and two certificate programs. The increased use of technology in the office means a high demand for job applicants with extensive knowledge of software applications. In this picture, faculty member Jean Chenu instructs students in one of the computer classrooms.

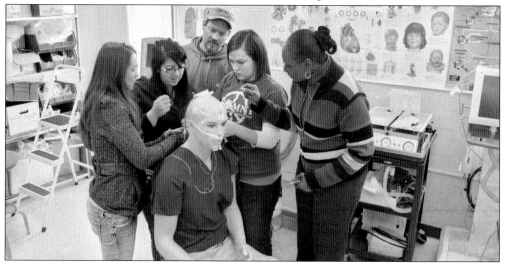

The polysomnography technology program at GCC was the first degree program in this field offered in New York State. With 84 different classifications of sleep disorders, the program provides students with the knowledge and skills to work in sleep clinics and laboratories. In this picture, program director Marshann Thomas (far right) is instructing students (from left to right) Amanda Poe, Amanda Knapp, Brian Cornbau, and Alesha Amend to prepare someone for a sleep analysis.

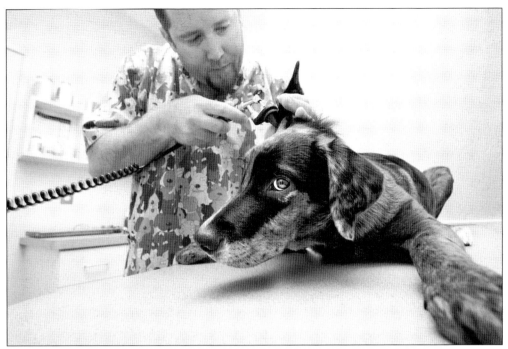

GCC is the only community college in Western New York to offer a veterinary technology program. Veterinary technicians work closely with veterinarians in private practice as well as in zoos, animal shelters, wildlife facilities, and research laboratories. Students complete three externships with hands-on training in veterinarian practices alongside licensed veterinary technicians and veterinarians. In the picture above, a student works to exam a dog's ear for a possible infection, and in the bottom picture, the student is preparing to work on a horse. The ability to work with large animals is important in a rural area with many large dairy farms.

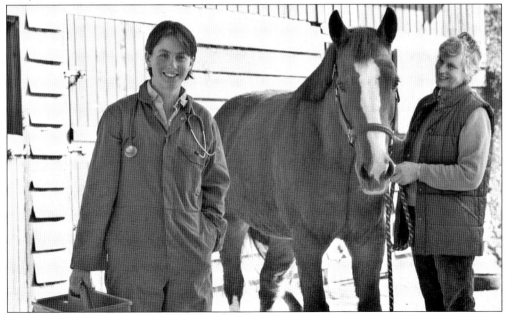

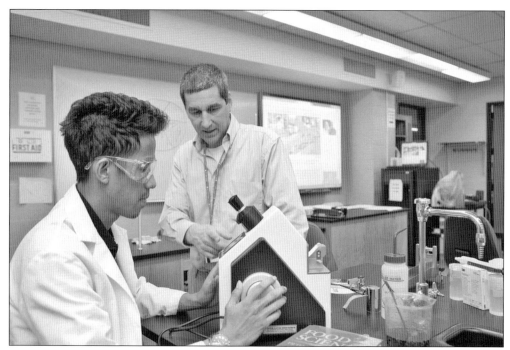

The college's new food processing technology program is meeting a growing need in Western New York for skilled workers in the food science manufacturing and processing industry. It is the only program of its kind offered at any of the 30 community colleges in the State University of New York. In 2015, the program purchased with grant support 12 new pieces of diagnostic laboratory equipment. In the picture above, instructor Greg Sharpe works with an international student from Timor-Leste, Jorguino Savio, to perform a sugar content analysis on a beverage using a refractometer. In the picture below, instructor Sharpe discusses pH and total acid content in beverages with students (from left to right) Wendy Vary, Bernadette Penkszyk, Arsenio Ferreira, and Jorguino Savio.

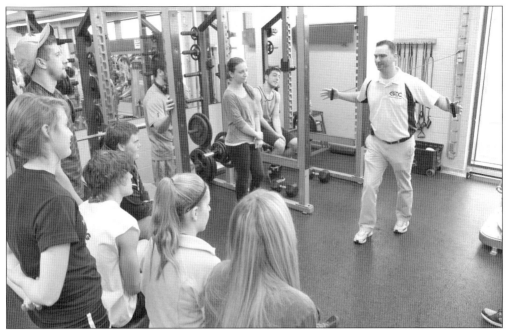

The physical education area offers degree programs in physical education studies and in sport management studies along with concentrations in fitness and recreation, in golf management, and in personal training. Pictured above is Eric Sandler, athletics trainer, instructing a class in the fitness center. In the picture below, a student is giving a golf lesson in putting. The screen is a golf simulator that students use to help with swing/stroke analysis and instruction. It provides data and feedback on a variety of issues such as swing speed, ball speed, impact, distance, and direction. It displays a 3-D trajectory in real time. The faculty and staff look forward to the move to the new Richard C. Call Arena in 2017.

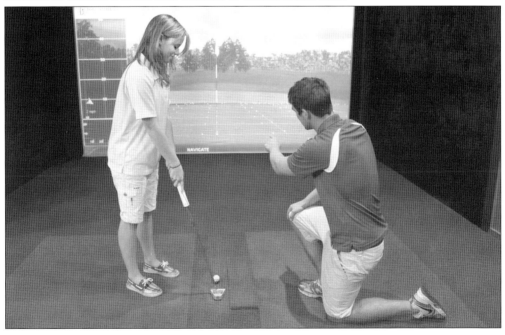

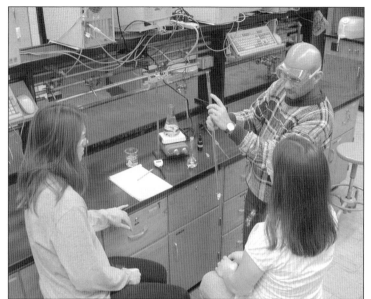

Science classes have been an important part of Genesee Community College curricula since the earliest years. Well-equipped labs have similarly long been a part of such courses. Science courses range from those intended for students majoring in a science field to those merely seeking an overview. In this picture, Dr. Rafael Alicea-Maldonado is instructing two students in a chemistry lab.

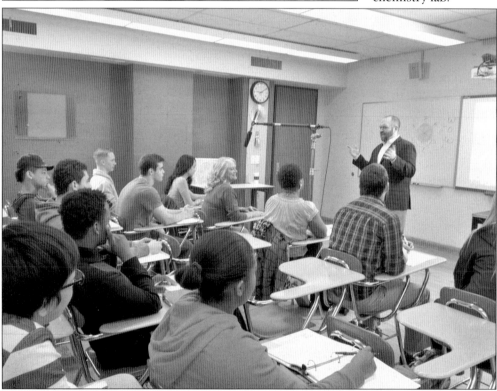

Ensuring that entering students are able to make a successful transition to college-level instruction, regardless of their backgrounds and levels of preparation, is a significant focus at GCC. First Year Experience (FYE) 100, a course pioneered by GCC professor Carl Wahlstrom and adopted by other colleges across the country, provides critical support to incoming freshmen. In this picture, Dr. Thomas Priester, director of transitional studies, is conducting a FYE class.

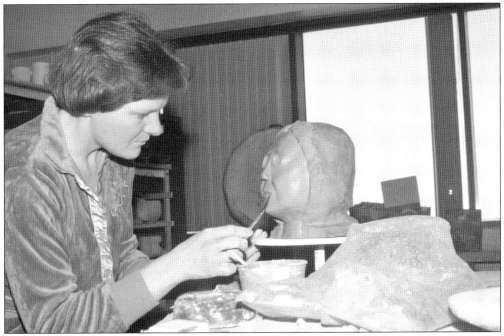

The Arts Center houses facilities in which students are able to experience working in many different media. In some instances, they may intend to pursue careers in the arts, but in other cases, they are simply interested in having a firsthand experience adjunct to other interests. This student demonstrates her talent in sculpting with clay.

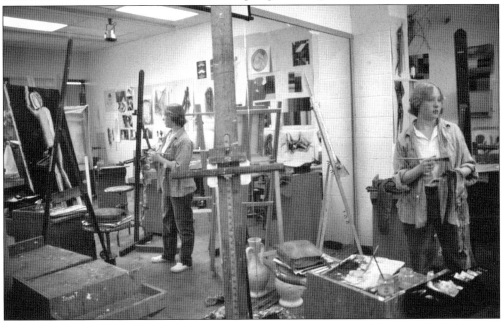

In this picture, an art course student stands back to assess her progress in painting a human figure. Note the mirror, a feature of the art studio that impacts lighting and also allows interesting perspectives. Students sometimes paint or draw images of live models. Such models are often students or faculty members who voluntarily serve in this role.

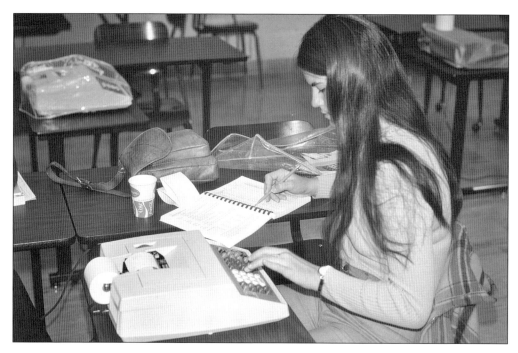

This and the next three sets of pictures depict some of the changes in the classes at GCC that are driven by technological advances. In the picture above, a business student from the early years of the college works with an adding machine that may be electrically powered but otherwise differs little from adding machines of decades before. In the picture below, digital art students are working on graphic design projects using state-of-the-art design software in the college's Mac Lab. Not a pencil, marker, or sketch pad is in sight as the resulting output is displayed on high-resolution flat-screen monitors or output to a laser printer.

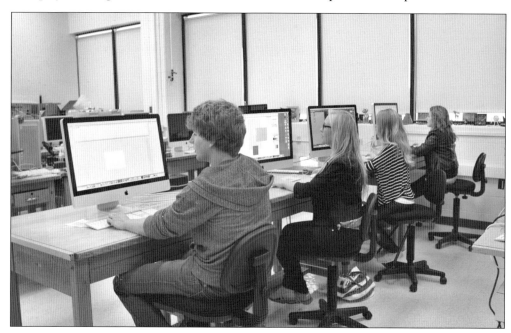

This set of pictures demonstrates changes made in courses utilizing computer labs. Genesee Community College early on adopted computers both in the classroom and for the offices of faculty and staff. As computers have become faster and more capable, the college has committed itself to updating both its hardware and software to keep abreast of the advances. In the above picture, note the small cathode ray screens. Compare them to the flat screens with liquid crystal displays in the picture below. Also note that in the picture above, the instructor would need to physically move from station to station while instructing students. Below, advances are shown that allow the instructor to monitor the work of individual students from a central location.

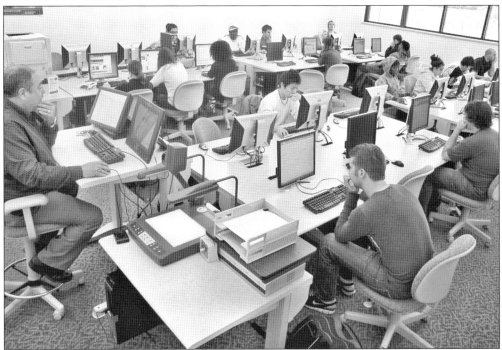

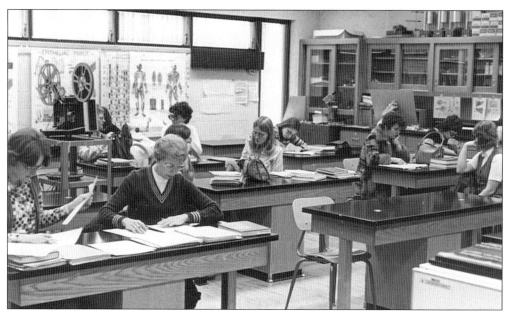

These two pictures show an older and then a recent class in anatomy and physiology. Note that the means of delivering the course information is dramatically different. For example, in the picture above, at the back of the room is a reel-to-reel movie-film projector. They were noisy and prone to malfunction, and the limited number of available projectors had to be wheeled from room to room. Budget constraints made purchasing a sufficient number of films and then updating them a challenge. In the picture below, a video projector is suspended from the ceiling. Connected to a computer, it allows instructors to readily display PowerPoint presentations they create, videos obtained for the purpose, and programming from the Internet. These represent major advances in instructional methodology.

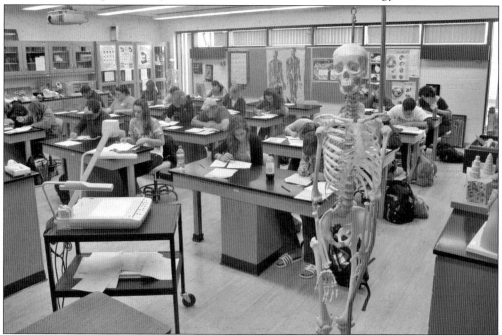

Even the music courses have been impacted by changing technology. Above, Dr. Theodore Ashizawa is shown conducting a choral group some time in the 1970s. The available equipment for his music classes was a piano (visible to the left), a record player, and a blackboard with a musical staff printed on the surface. Below, in a later view of the music facilities, a number of changes are visible. They include a keyboard for generating music electronically and computers for using either Finale or Sibelius, software programs for composing music. Many of the music classes are currently taught online.

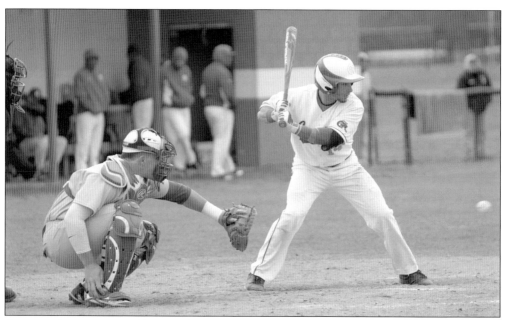

Genesee Community College has had a strong sports program for many decades. That has been true of both men's and women's sports. Particularly promising athletes have commonly been actively recruited from area schools and beyond. In the picture above, a member of an opposing men's baseball team prepares to catch the ball as a GCC player seeks to drive it into the outfield. In the picture below, a member of the women's softball team, the Lady Cougars, slides into a base as an opposing team member attempts to tag her out. In March of each year, both the baseball and softball teams begin their spring training with visits to a southern state.

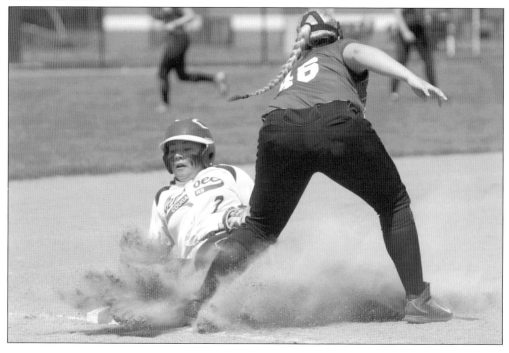

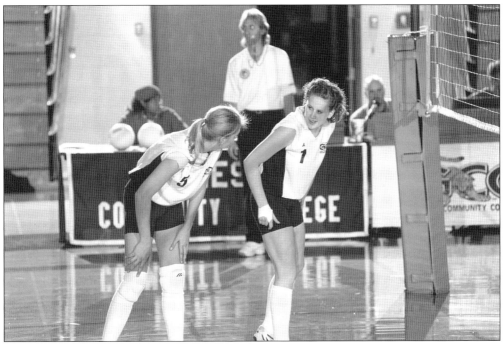

In the picture above, members of the women's volleyball team are participating in a game in the Anthony T. Zambito Gymnasium, named for the longest-serving college trustee. Over the years, the Lady Cougars have been impressively successful. Four times in just one decade, they advanced to the National Junior College Athletic Association (NJCAA) national volleyball championship tournament. In the picture below, members of the men's lacrosse team celebrate capturing the NJCAA national championship by defeating Onondaga Community College on their home field and breaking the latter's series of seven consecutive national titles. The lacrosse win was the second national title in Genesee's 50-year history, the first being a national bowling championship in 1971.

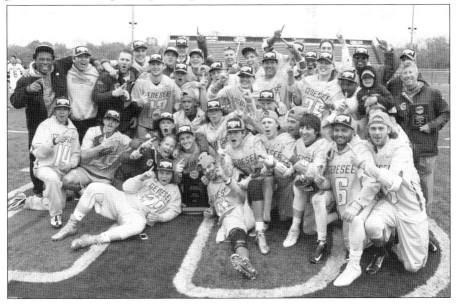

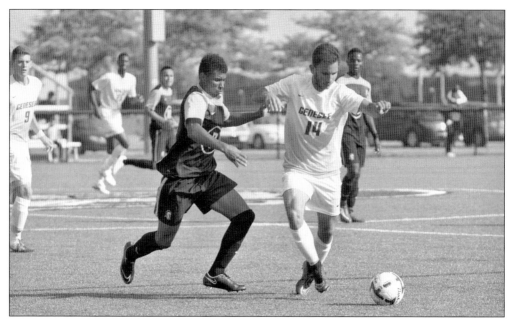

Soccer, once a sport with little following in this country, has come to attract considerable interest. Genesee Community College fields both a men's team and a women's team. Within its division, the women's team has been ranked no. 1 nationally. Both women's and men's basketball teams have been especially strong. The women's team has won at least six regional championships and competed in six national championships. There have been years when the women's team has been ranked among the top 20 in the nation, and it was once as high as sixth among schools in its division. The men's team has also been to the Junior College Athletic Association's national championships. The picture below shows GCC players competing against Rose College on one such occasion.

Six

DEVELOPMENT OF CAMPUS CENTERS

For the first 24 years after Genesee Community College came into existence, its facilities consisted solely of those situated on the main campus at Batavia. Then, although classes had sometimes been taught in public school locations, beginning in 1990, the college began to establish campus centers located as far as 43 miles distant. In order of appearance, the existing centers are at Albion, Warsaw, Arcade, Dansville, Medina, and Lima. For 17 years, there was also a center at Lakeville, but it was replaced by the current one at Lima, the newest of the centers. The Lima center opened in 2009.

For many decades, New York State has had a goal of having a community college within a 25-mile commuting distance for every state resident. The GCC campus centers help meet this objective. Several of the centers are in areas effectively unserved by other institutions of higher education, especially other public institutions offering low-cost two-year degrees.

The centers generally provide many of the high-tech facilities offered on the main campus at Batavia. In addition, the courses are frequently taught by full-time faculty members who also teach on the main campus. Students at the centers qualify for the same financial aid as students attending the Batavia facility. They also have access to counseling, tutoring, and other services that are often critical to academic success. Some students attend classes at the main campus as well as at one or more of the centers.

There is one significant difference between the main campus at Batavia and the centers. The latter are unique in using structures that are leased rather than owned by Genesee Community College. The only comparable instance on the main campus involves the nursing program, which is housed in a section of the MedTech building owned by the Genesee County Economic Development Center.

The first campus center was established in 1990 at Albion in Orleans County. The county has a population of 42,883. Albion, the county seat, has a population of 6,056. The Albion center is approximately 17 miles north of Batavia. In the fall of 2015, enrollment was 206 full-time and 37 part-time students. There are no other college campuses in the county other than GCC's Medina Campus Center 10 miles to the west. Located at 456 West Avenue, the Albion Center building is leased to Genesee Community College. There are two computer labs, six high-tech smart classrooms, an art room, a quiet study lab, a student lounge, and an outdoor patio.

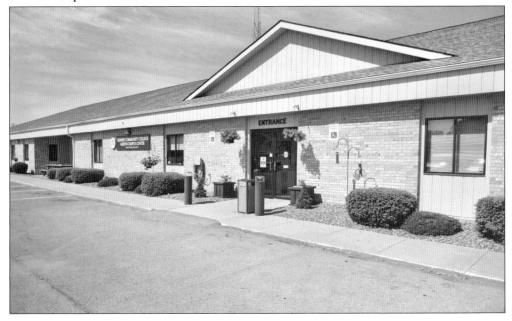

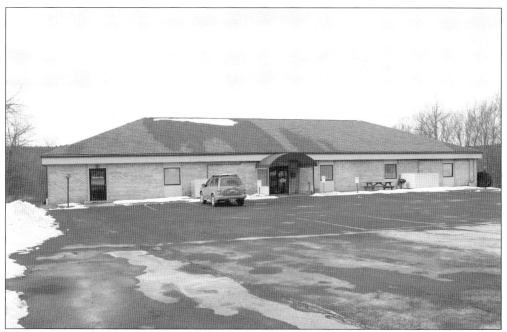

The next center was established in 1991 at Warsaw in Wyoming County. The county has a population of 41,155, and Warsaw is the county seat. It has a population of 3,473. The Warsaw center is approximately 21 miles south of Batavia. In the fall of 2015, enrollment was 131 full-time and 45 part-time students. There are no other college campuses in the county other than a GCC center in Arcade. The original center was located at 450 North Main Street. In 2002, it was relocated to 115 Linwood Avenue, where it shares a building occupied by the YMCA. The picture above shows the North Main Street building, and the picture below shows the current location. The instructional space is leased to Genesee Community College.

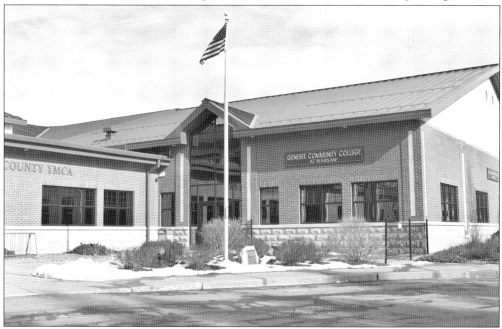

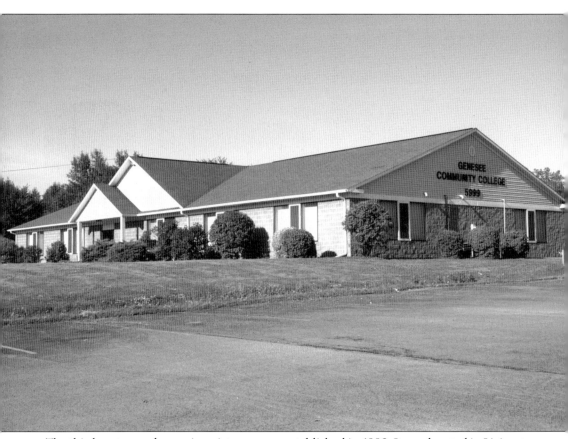

The third center, no longer in existence, was established in 1992. It was located in Livingston County at 5999 Big Tree Road, Lakeville, approximately 32 miles southeast of Batavia. When the center was opened, there was no other college in the county other than SUNY Geneseo, a four-year selective intuition with both undergraduate and graduate programs. The Lakeville center was closed in 2009 and replaced with a center in Lima.

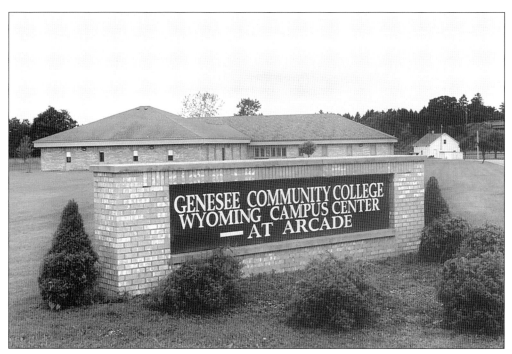

The fourth center was established in 1995 at Arcade in Wyoming County. Arcade has a population of 2,071. The Arcade center is approximately 41 miles southwest of Batavia. In the fall of 2015, enrollment was 136 full-time and 41 part-time students. There is no other college campus in Wyoming County other than the GCC center in Warsaw. Located at 25 Edward Street, the building is leased to Genesee Community College. Renovated in 2001, the campus has a science lab, seven classrooms, two computer labs, smart classrooms, and video-conferencing capability. There is an outdoor memory garden that displays a unique student-created metal sculpture embedded in a bedrock boulder relocated from the Batavia campus. The garden was created in collaboration with the late Simon Griffis and his artistic team from nearby Griffis Sculpture Park.

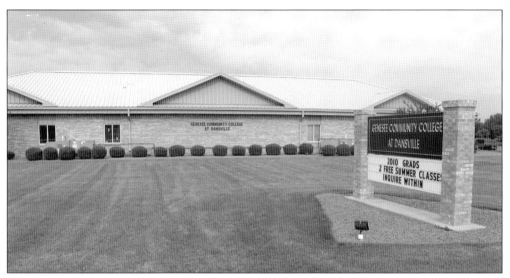

The fifth center was established in 2002 at Dansville in Livingston County. The location is approximately 43 miles southeast of Batavia. Dansville has a population of 4,719, and Livingston County has a population of 65,393. The picture above shows the first center in Dansville. It was located on Route 63 just outside the village in a building leased to Genesee Community College. The picture below shows the current center located at 31 Clara Barton Street. It, too, is a leased structure. In many respects, the Dansville center nearly matches and in one respect actually exceeds the facilities and features found on the main campus in Batavia. That will be evident in the following pictures.

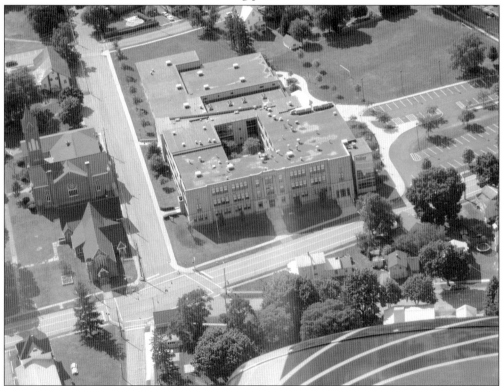

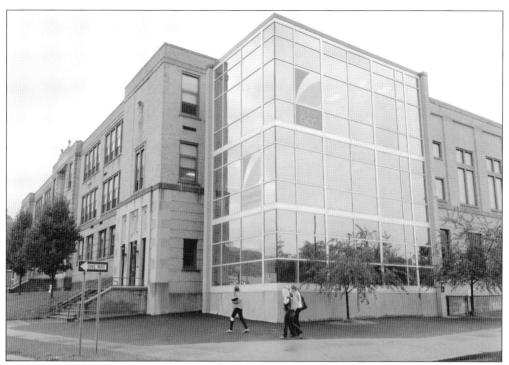

The current location is in the former Dansville Middle School. The building is just off Main Street in downtown Dansville. An interesting and attractive feature is the atrium that can be seen below. Unlike the other GCC centers, the Dansville facility, due to its previous use, features a full range of resources. These include a gymnasium and an auditorium. This helps to explain the motivation behind the move from the original location. There is no other college in the county except for the GCC center at Lima and SUNY Geneseo.

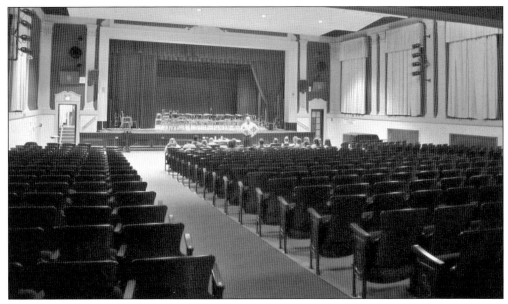

The picture above shows the auditorium space in the building. Note the balcony and ample stage space with multiple curtains that can be drawn. The auditorium has 550 seats, exceeding the size of the Stuart Steiner Theatre on the main campus in Batavia. The picture below shows the gymnasium. Note the well-maintained hardwood floor and the bleachers that can be folded down to seat spectators. The gymnasium provides space for a regulation basketball court. It also can be used for other athletic competitions, including volleyball. The auditorium is more than ample for all college convocations, including orientation sessions and graduation ceremonies.

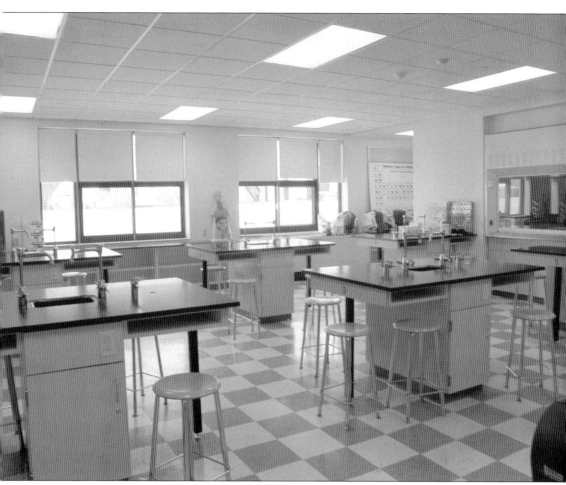

In the fall of 2015, the Dansville center enrolled 147 full-time and 57 part-time students. In addition to the gymnasium and auditorium, students have access to a large number of classrooms, modern science labs such as the one shown here, a ceramic studio, student lounges, and a silent study room.

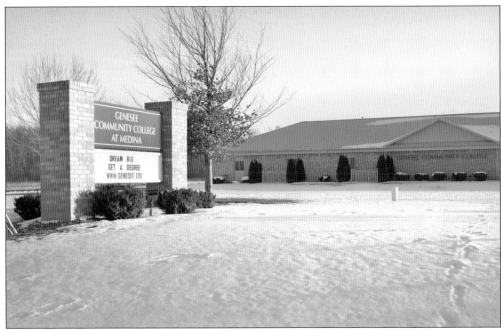

The sixth center was established in 2007 at Medina in Orleans County. The location is approximately 22 miles northwest of Batavia. Medina has a population of 6,065. In the fall of 2015, the Medina center enrolled 137 full-time and 46 part-time students. There are no other college campuses in the county other than another GCC center 10 miles to the east in Albion. Located at 11470 Maple Ridge Road, the building is leased to Genesee Community College. The picture above shows the front facing Route 31. The picture below shows the rear opening onto a spacious parking lot.

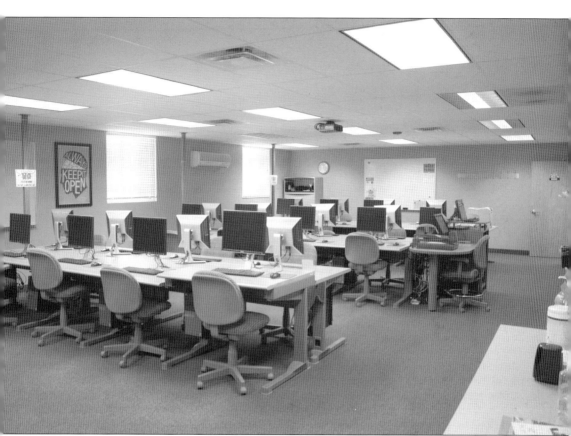

Pictured is the computer lab at Medina. In addition to this lab, there is a multidisciplinary science lab, a video-linked classroom, and five additional classrooms. More than 40 college courses are taught each semester. Classes are offered in accounting, biology, chemistry, college composition, US history, human services, and statistics, as well as many other subjects.

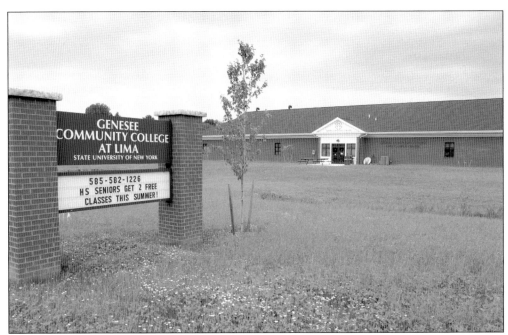

The center at Lima was established in 2009. It replaced the center at Lakeville, which closed the same year. It is located in Livingston County not too distant from the Lakeville site. Lima has a population of 2,139. The Lima center is about 32 miles southeast of Batavia. Located at 7285 Gale Road, the building is leased to Genesee Community College. The picture above shows the front as seen from Route 15A. The picture below shows the rear as seen from the parking lot. In the fall of 2015, there were 43 full-time and 46 part-time students enrolled. The only other college campuses in the county are the GCC Dansville center, about 25 miles to the south, and nearby SUNY Geneseo.

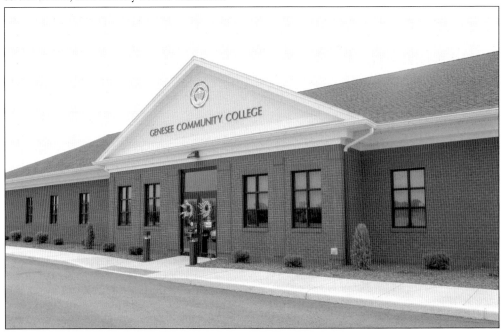

Seven

THE STUDENTS

From the 378 who came on opening day in 1967 to the 6,521 who registered for classes in the fall of 2015, students are the reason Genesee Community College exists. There have been changes in the composition of the student body and in the opportunities available to students. In the early years, the majority of students were preparing for transfer. Today, career programs that prepare students for the workforce are more prevalent. The number of student attending full-time was 75 percent or higher in the beginning, whereas today it is slightly under 50 percent. A significant portion of this difference is attributable to the Accelerated College Enrollment (ACE) program for high school students.

GCC students have over 40 clubs and organizations from which to choose. The Student Government Association is active on campus and provides a formal mechanism to influence college policy. Students are recognized for outstanding effort and contributions to the college through Phi Theta Kappa, the community college honor society, and through Chancellor's Awards granted by the State University of New York. Students who need assistance are helped by the Center for Academic Progress (CAP), which provides tutors and other tools to help students succeed.

Students now have many options for where and how they elect to take courses. The six campus centers in the three surrounding counties provide opportunities that were not available prior to 1990. Students may take all their classes at one of these locations or combine them in another way that works for them. There is also the option of online classes. Today, students can take the majority of a program or, in some cases, the entire degree program online anywhere in the world.

The college continues to work to find ways to ensure student success. The construction of the new Student Success Center is a testament to this commitment to current and future students.

The admissions office is the first contact that many students have with Genesee Community College. In this picture, staff member Ebony Ross greets a prospective student. The staff works closely with deans and directors to ensure students have the most current information on programs. Today, much of the information for admission is on the college's website, but the personal contact often makes the difference for the applicant.

Orientation before the semester begins prepares the new students for the first day of classes. Family is invited, and there is a mix of information and fun, as seen in this picture. Students attend sessions, take tours so it is clear where important offices are located, obtain identification pictures, and meet other students.

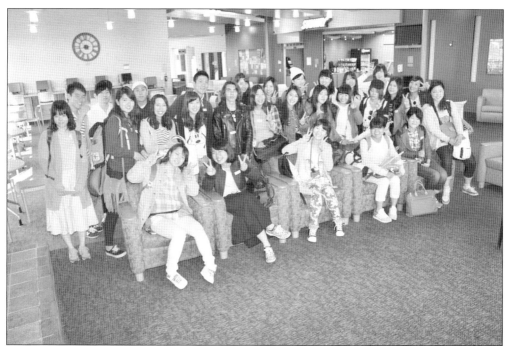

The number of international students attending GCC exceeds 140. A significant portion of the students are from Japan, where the college has agreements with the Japan College of Foreign Languages and the Human International Universities and Colleges Consortium. Other students come from dozens of additional countries. The students add an essential element to the diversity of the college. Often, the students become part of the Global Education Committee's offerings such as lunches with food from around the world and displays of different modes of dress. A staff person is specially assigned to assist the international students in navigating the new environment.

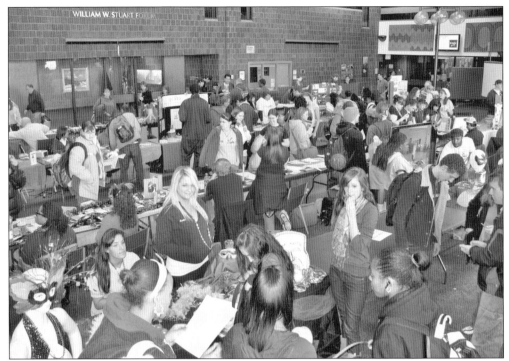

Each fall, the Student Activities Office hosts a club fair for students to become acquainted with the more than 40 clubs and organizations that are available on campus. Representatives from each club staff a table in the forum so students can stop and talk with someone and receive information. Local agencies are present to let students know what is available in the community. In the picture below is the Veterans Lounge, a place where student veterans can go to receive assistance or just relax with others who share a common background. The lounge reflects the growing number of veterans attending the college and the efforts to meet their needs.

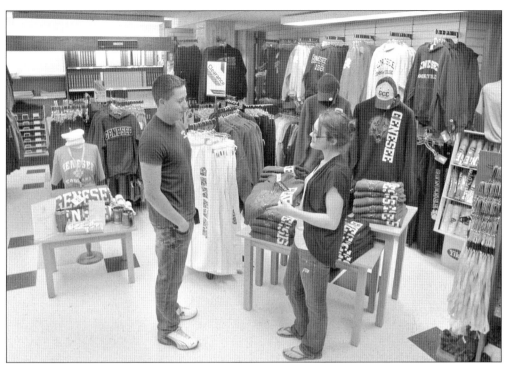

The college bookstore, managed by Barnes & Noble, sells a variety of items that go beyond the traditional books and supplies. GCC apparel is a major item in the range of offerings. This has increased in recent years, when staff are encouraged to show their college spirit by wearing GCC apparel on the first Friday of every month.

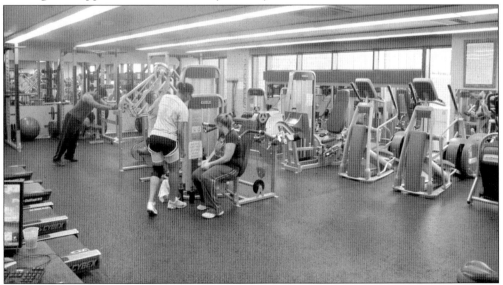

The fitness center is part of the physical education complex. It is available to all students except when classes are in session. There is also a dance studio on the second floor of the Arts Center that has a daily schedule for an aerobics class. Wellness has been a focus of a five-year Title III grant and is a major component for the planned Richard C. Call Arena, slated to open in 2017.

The college cafeteria is run by an outside vendor and underwent significant renovation in the last few years expanding the kitchen and food distribution areas. Previously, all customers entered a single line, but now separate food stations are available for salads, grilled and prepared foods, and beverages. A healthier menu has also been introduced. Vending machines are located across the cafeteria under the *Faces of Genesee* photo mural that features student portraits. Hanging above the seating area are flags from around the world, each one representing an international student who attended GCC. The Haudenosaunee Confederacy, commonly known as the Iroquois Confederacy, is also represented.

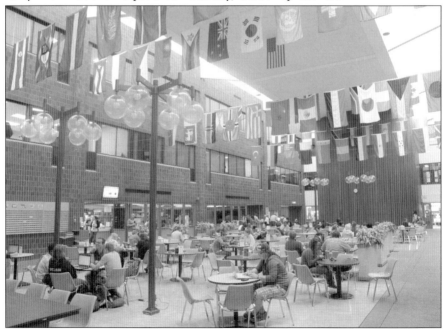

Each semester, outside performers come to GCC to entertain the students—usually during the Common Hour, held two days a week in the early afternoon when no classes are scheduled. In the picture above, a hypnotist is demonstrating his skills on a student. In the picture at right, a mime works in the cafeteria. Other times, nationally recognized speakers have presented to students on topics of current interest. In addition to activities in the open areas such as the forum and cafeteria, smaller presentations are held in the Stuart Steiner Theatre or the large media-equipped lecture hall in the BEST Center.

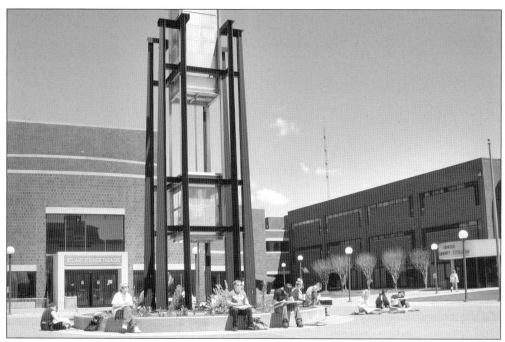

When the weather permits, some classes take advantage of the opportunity to work outside. Pictured above is a class of art students drawing the Conable Building as they gather around the clock tower. The picture below shows the Honorary International Peace Garden, which is between the Conable Building and the main building off the connecting corridor. The garden is the inspiration of alumna Paula Savage, who wanted to establish a legacy at GCC to remind students of the importance of peace in the world and the role that each person plays in fostering that peace. It is fitting that this peace garden exists at GCC, since the International Peace Garden Foundation stresses the importance of education in the peace process.

Campus Safety is charged with ensuring that the campus is a safe place for people to work and learn in an environment that is welcoming. Campus Safety employs eight full-time and seven part-time officers who work 24/7 shifts so that there is never a time when an officer is not available on campus. The officers patrol the exterior areas, especially the parking lots, and often assist with routine tasks such as helping start cars. As seen in the picture at right, the college has invested in a system to electronically monitor the facilities. The identification cards for students and staff have been upgraded, and in recent years, there has been increased training for the officers.

Each year, the State University of New York presents Chancellor's Awards for Student Excellence to students who have demonstrated excellence in the classroom and made significant contributions to the college and the community. Students are nominated by faculty and staff as well as by fellow students. Many students have been awarded this honor. A reception for the students is held in the state capitol in Albany each spring. Pictured below are three students who have received Chancellor's Awards. From left to right are Danielle Collins, Jennifer Bryant, and Kathryn Scarborough.

Phi Theta Kappa is the international honor society for community college students. Alpha Iota Upsilon, GCC's local chapter, was awarded Most Distinguished Overall Honors in Action Project in 2016. To be inducted into the honor society, a student must have completed 12 semester hours of course work with a GPA of at least 3.6 and possess recognized qualities of citizenship. The chapter has nearly 200 current members and over 3,000 alumni. In the picture below, students who have received scholarships from the college are honored at the "Discover the Stars" reception held each September. GCC awards about $300,000 annually in scholarships to students based on areas such as academic excellence, financial need, and field of study. The GCC Foundation has been very successful in its campaigns to raise funds for student scholarships.

In 2010, the college began a yearly alumni weekend. Prior to this, alumni had received newsletters and invitations, but now former students are also invited back to campus for a weekend of reminiscences and activities. Pictured at left is Jackie Christenson, alumni coordinator, who has been responsible for planning the weekends as well as a range of other alumni correspondence and activities. Pictured below is Pres. Stuart Steiner with the GCC cougar mascot, G-Dub, who is wearing an alumni T-shirt. The alumni office continues to send a newsletter twice each year to keep 24,000-plus GCC graduates in touch with what is happening at the college.

Students involved with GCCRAKtivists promote International Random Acts of Kindness Week in February and World Kindness Day in November. People are encouraged to support the kindness movement. On World Kindness Day, donations of money and supplies are given to the Genesee County Animal Shelter. The students in the picture are wearing their "GCC—my *KIND* of place" T-shirts as they promote kindness on campus.

Pep rallies are an important part of competitive sporting events. In this picture, students are gathering in the college forum to provide support to the teams. Onstage, the GCC cheerleaders are leading the crowd in a series of cheers. In addition to GCC's teams, the cheerleaders have also competed in regional and national tournaments and earned many trophies and titles.

In this picture, an ice-cream social is being held inside, but during Spring Fling the activities are outside. Other events are part of the schedule each year. For example, GUSTO! (Genesee Unites to Support Team Opportunities) has hosted donuts and cider during Halloween costume contests. GUSTO has existed for over 20 years for the purpose of fostering employee morale and providing opportunities to engage in the college culture.

College Village, the student housing complex adjacent to the college, hosts an orientation in the fall and a celebration of spring just before the semester ends in May. Food is always a major ingredient. Here, hot dogs are being grilled to complement the other typical picnic fare. A young guest on the far right seems to already be enjoying the final product.

Eight

INVOLVEMENT WITH THE COMMUNITY

Genesee Community College has taken the term "community" very seriously, involving itself in surrounding communities and they in the operation of the college. This chapter provides multiple examples of this fact.

Perhaps the highest-profile involvement with local communities is represented by the BEST Center. "BEST" stands for "business and employee skills training." The mission of the center is to provide quality training at a reasonable cost to improve local business operations and enhance the skills of individual employees. In a recent five-year period of operation, the BEST Center served over 2,350 groups and businesses, trained over 42,800 individuals throughout the GLOW region, and secured more than $2.25 million in training grants.

Under the auspices of the BEST Center, the Rural Police Training Academy has provided training to police recruits. The academy dates back to 1986, when it was known as the Rural Police Training Institute. By late 2015, there had been 628 graduates. In the GLOW region, probably 75 percent of the current police officers are graduates of the Rural Police Training Academy.

The Genesee Community College Foundation, a charitable organization affiliated with the college, builds philanthropic and volunteer support for the college. Among its many activities, the foundation funds scholarships and grants for more than 300 students each year. It has engaged in fundraising campaigns to support the construction of new facilities. The foundation also operates College Village, providing residence for 455 students.

In addition to examples such as those cited above, GCC serves surrounding communities indirectly through the involvement of individual faculty and staff members. As an illustration, employees of the college have served as supervisors in local townships, town and village justices, members of the Batavia City Council, appointed public historians, and leaders in many community organizations such as the Genesee County Community Services Board and the Landmark Society of Genesee County.

The BEST Center was established in October 2003. It grew out of GCC's former offices of continuing education and workforce development. The BEST Center has been described as not just an economic resource but also a profit-building resource. The Genesee County Chamber of Commerce named it the 2004 Innovative Enterprise of the Year. Shortly afterwards, the BEST Center received the National Best Practice Award for Community Economic Development from the Association of Community Colleges. In its first year of operation, the center served more than 182 businesses and organizations. The previous high at GCC had been about 80 in number.

The sort of training provided by the BEST Center for employees of local businesses and organizations is partially funded by grants obtained by the center (see the picture above). A major source of such funding has been the New York State Department of Labor. In its first year of operation, the BEST Center procured about $750,000 in grants. The previous high at GCC had been $97,000. In addition to leadership management and job skills training, the BEST Center hosts workshops and seminars (see the picture below). It also offers consulting services and provides conference center and support services. Training sessions include online courses. Training may be as brief as an eight-hour course or perhaps last a full year.

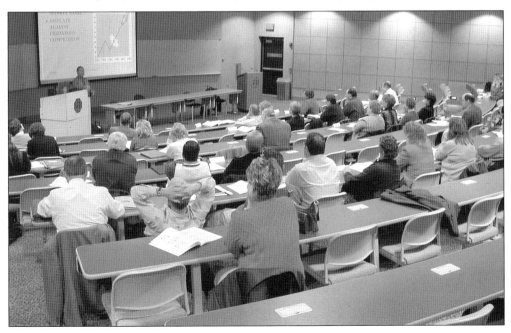

The Rural Police Training Academy (RPTA) operates under the auspices of the BEST Center. Primarily formed to serve the GLOW region, it has now come to also serve many other areas of Western New York. In the GLOW region, roughly 75 percent of the police officers are RPTA graduates. Currently, this includes the police chiefs in Arcade, Attica, Albion, Batavia, Mount Morris, Nunda, and Warsaw.

The Genesee Community College Foundation provides major financial support to the college. Through it, individuals, businesses, and organizations in surrounding communities have given generously over the years. The Wall of Honor shown in this picture, located in the forum outside the library, displays plaques honoring those who have donated. The four categories represent donations ranging from $1,000-plus to $100,000-plus.

The Genesee Community College Foundation's board is composed of leading civic and business leaders, all volunteers, who guide the foundation's fundraising programs, endowment funds, and stewardship activities. It also serves as an advocate for Genesee Community College. The foundation sponsors both a program of outreach to and activities for the 24,000-plus graduates of the college. Since 2013, it has sponsored "Creating Our Future Together," a comprehensive funding campaign to support the construction of a student success center and an events center (see chapter 9). An annual fundraising event is Encore, an evening of good food and entertainment with a meal in the forum (above) and dessert in the student center (below).

The major entertainment at the annual Encore events has been concerts held in the Stuart Steiner Theatre. Here, the renowned Buffalo Philharmonic Orchestra performs seasonal favorites under the baton of the distinguished conductor Paul Ferington. The proceeds from the Encore events are used specifically for the Genesee Community College Foundation Scholarship Fund.

Another manner in which the college has become involved with surrounding communities has been through its sponsorship of "A Tale for Three Counties." Each year, an area-wide series of book discussions occurs involving a single book selected for that purpose. In 2005, the book chosen was *In the Bleak Midwinter*, written by Julia Spencer-Fleming, shown above.

Spencer-Fleming's selection occurred the third year of the book-discussion event. That was also the first occasion on which GCC became a participant. Since 2005, the college has been a cosponsor every year. Copies of the book chosen for a particular year can be borrowed or purchased at the GCC library. In the picture above, Spencer-Fleming is shown discussing her novel at a book discussion session being held at the college. Readers are encouraged to submit a review of the chosen book prior to any of the regional discussion sessions. Those who write the best reviews are invited to a lunch with the author. Following each of the discussion sessions, readers also have an opportunity to have their book autographed by the author. In the picture below, a book-signing is taking place at the college.

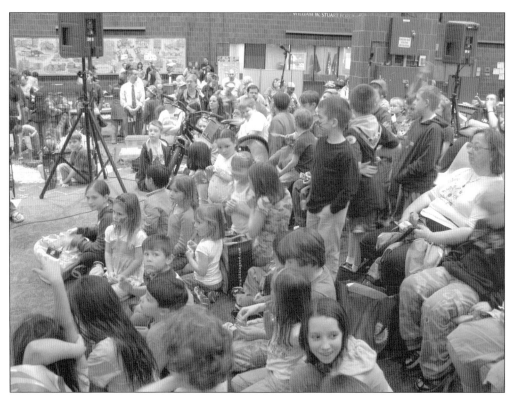

Another example of the college's involvement with the community is the annual Cool Kids Eco-Fest. The 10th such event was held in 2015. The activities are free to everyone. Participants are asked to bring recyclable products that earn them Eco-Raffle tickets. Examples of such products are eyeglasses for the Lions Club, cellular phones for the YWCA, paperback books collected for American troops, and reusable bike parts for Trailrider Bikes of Orleans County. Cool Kids Eco-Fests include exhibitors, exotic wildlife displays, and make-it, take-it activities, as shown above. Face painting, as shown below, is also a popular attraction.

Students typically have limited disposable income and often have limited time to donate to community projects. However, that does not preclude GCC students being able to play important contributing roles. One such way is through donating blood. Red Cross drives have been held on a regular basis. Shown here is one such drive taking place in the William W. Stuart Forum.

For many years, students in the Business Forum Club have raised money for the annual United Way campaign. Rubber ducks, sold by the students, are set free in the college pool. The owner of the first duck—propelled by a current generated by members of the GCC swim team—to float to the end of the pool is declared the winner.

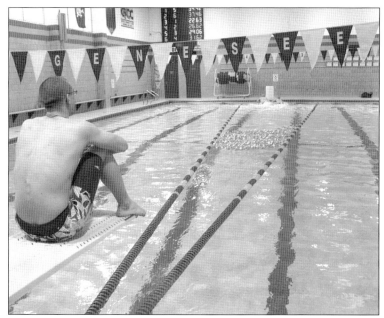

GCC students have also supported the larger community through Operation Paperback. They have collected used paperback books for military personnel. The drive was originally the idea of Tom Maniace, who used it as part of a required project for his resident assistant position at College Village. Maniace is shown here packing 200 boxes for delivery overseas.

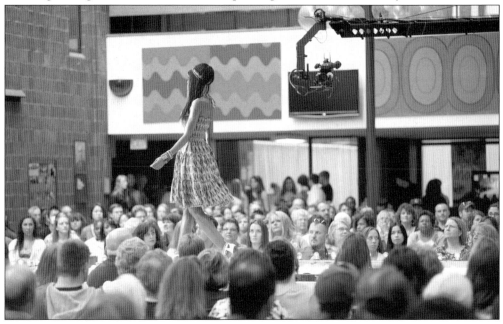

For 35 years, fashion students at GCC have completed their studies by enrolling in the capstone fashion show production course. The resulting production is held in the forum and has grown to be the largest fashion show in Western New York. It draws upwards of 1,600 attendees from the area.

Through the years, fashion show students have developed excellent relationships with well-known retailers such as Francesca's, PacSun, and Rue 21, which feature clothing and accessories in the show. M.A. Carr Bridal has donated numerous wedding gowns, some repurposed into new garments. With the mantra of learning by doing, fashion students build dynamic portfolios that have resulted in successful transfers to FIT and LIM in New York City and the International Fashion Academy in Rome.

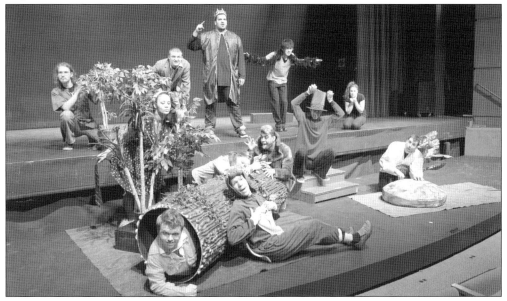

GCC also brings other forms of quality entertainment to residents of surrounding communities through productions held in the Stuart Steiner Theatre. Productions have ranged from plays by the Forum Players, as shown here, to performances by the Genesee Symphony Orchestra, nationally recognized stand-up comics such as Etta May, and regional semiprofessional musicians such as the Rochester Ratpack.

The Rosalie "Roz" Steiner Art Gallery's mission is to foster community involvement in the arts while embracing learning experiences for fine arts majors, faculty, and staff. The college regards itself as an integral part of area arts events and works cohesively with the regional arts organizations in an effort to enhance the Western New York arts community.

Genesee Community College has served surrounding communities by providing a space for exhibits and exhibitions. For example, in this picture, nonprofit organizations are presenting information about the functions they perform and the opportunities they provide for involvement in and by the community. Note that the visitors to the exhibit appear to be from a broad cross-section of residents.

This picture shows an art exhibit featuring the work of area artists. Note the amount and range of art that is displayed, from jewelry to photographs to paintings. Other community events held in the forum have included displays by area museums and historians. The space available for such functions will be dramatically increased by the construction of the Call Arena (see chapter 9).

Genesee Community College has also brought to surrounding communities an opportunity to see, hear, and interact with national figures. That opportunity existed from the earliest days when, for example, Ralph Nader visited "Valu Tech." In more recent years, dignitaries visiting GCC have included Jimmy Carter, George H.W. Bush, Hillary Clinton, Louise Slaughter, and Jack Kemp.

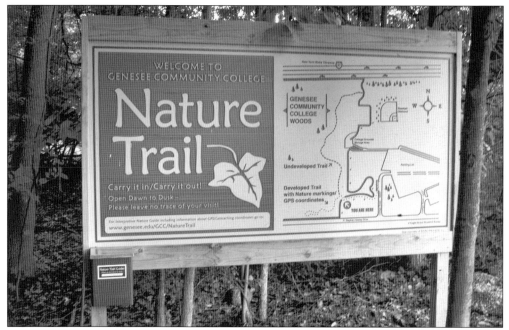

The Genesee Community College Nature Trail provides both recreational and educational value for the larger community beyond the college campus. The trail loops through the southwestern woodlands of the Batavia campus. There are more than 20 markers placed along the trail to give visitors of all ages and interests an introduction to the natural beauty and resources of the area. A corresponding nature trail guide can be used to guide one's walk. The ecological aspects visible to visitors range from maple trees to maidenhair ferns to American beeches to bluebirds. The nature trail is free, open to the public from dawn to dusk, and has but one rule: "leave no trace of your visit, carrying out what you carry in."

The college also serves residents of the GLOW region by providing college courses for area high school students, and has been doing so since 1982. The first classes offered on campus for high school students began in 2000. This photograph shows a class enrolled in Psychology 101. The instructor is associate professor Elise Banfield, a member of GCC's full-time faculty.

For several years, GCC provided courses inside the maximum security prison at Attica. The classes were begun following the notorious 1971 riot. Genesee Community College was the first college in the state to have an inmate education program that was degree granting. The classes were taught by faculty from the Batavia campus. The program ended in the 1990s, when the federal and state governments withdrew financial aid for prisoners.

Faculty, administrators, and staff have a long history of serving in community organizations. Among the many examples are these individuals who belonged to organizations such as the Rotary Club, United Way, Leadership Genesee, the boards of hospitals, and arts, cultural, and civic groups. From left to right are (first row) Larene Hoelcle and Stuart Steiner; (second row) Richard Ensman Jr., Robert Knipe, and Ray Chaya.

Nine

PLANS FOR THE FUTURE

In 2011, Pres. Stuart Steiner retired after 44 years with the college. Dr. James Sunser was selected as the fourth president of Genesee Community College. Dr. Sunser inherited a college that had grown immensely since its beginning in 1967. Soon after, President Sunser undertook an ambitious planning and construction initiative to add two new buildings and transformative new services to the campus with ground breaking scheduled in April 2016. The board of trustees embraced this vision. Continuing its long tradition of commitment to the college, the Genesee County Legislature offered its financial support for the projects.

The Student Success Center will bring to fruition a reenvisioning of how to engage students from the time of inquiry until the point of involvement as alumni. The Student Success Center will have staff that will focus on ensuring that students achieve the goals they have set for their higher education experience.

The Richard C. Call Arena will enhance student life and be a major college asset in engaging the community by bringing in conferences and events. It will be the largest event space between Buffalo and Rochester, a strategic location for such activities. The added focus on wellness will provide resources for students, staff, and community members to learn, exercise, monitor, and improve on a variety of health issues.

The academic area is also looking to the future to enable students to be prepared for the changing employment market of the 21st century. A new program starting in the fall of 2016 is nanotechnology. This program studies the microscopic world at the atomic level and applies this to an enormous variety of fields and industries. Nanotechnology is a collaborative program with Erie Community College in Buffalo and with the Western New York Science, Technology, and Advanced Manufacturing Park (STAMP), projected to open in western Genesee County in 2017. GCC continues its long tradition of being on the forefront of new programs that directly provide opportunities to the citizens of the GLOW region and beyond.

Pres. James Sunser was inaugurated on May 5, 2012, as the fourth president of Genesee Community College. Since his arrival he has worked to ensure the continued success of GCC. Foremost has been the effort to plan for two new buildings. However, as Dr. Sunser has said many times, it is the people that have made and will continue to make GCC an institution that goes "Beyond Expectations."

The 18,478-square-foot Student Success Center will be attached to the Conable Technology Building by an enclosed walkway. The two-story building will more fully enclose the current entrance plaza, creating a quadrangle appearance. The front of the building faces the parking lot, making it the first building a visitor sees when entering the college, providing prospective students with both physical and academic ease of access to GCC.

The entrance to the Student Success Center will be an open space with immediate assistance and comfortable seating. The focus is on maximizing how students are engaged from the moment they enter the campus. Higher education is increasingly being measured against issues of retention, persistence, completion, and transfer. The center will revamp how GCC works with students.

The stairs in the Student Success Center will lead to the second floor, which will mostly be for processing of information. The vast majority of the student interaction will be with the student success coaches located on the first floor along with some content experts from each student service area to assist as needed. The building is the tool, but people are the reason students will succeed.

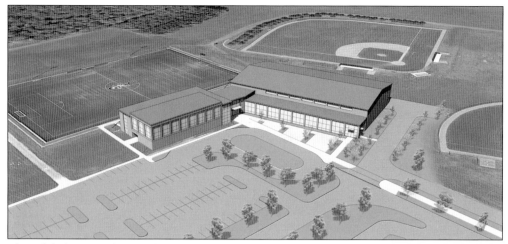

The 56,614-square-foot Richard C. Call Arena will be the first freestanding building on the campus. It will be positioned near the current athletic fields and will be about a five-minute walk from the entrance plaza. The GCC Foundation, with the support of the community and staff, raised funds for the new building, reflecting the level of community support for the facility and the college.

The arena will have three sections with two stories. In the third section, there will be a 20,400-square-foot multipurpose floor that will serve as basketball courts as well as lacrosse and soccer fields and can also accommodate over 2,500 people for graduations and events such as concerts, conferences, and trade shows. It will be the largest single space in Genesee County.

The arena will focus on physical wellness and include a state-of-the-art fitness center and space for classes that teach participants the fundamentals of healthy living. A two-lane walking course in the field house will allow students, college personnel, and community members to walk indoors when needed. Some faculty will have offices in the complex, as will the coaches of the college's sports teams.

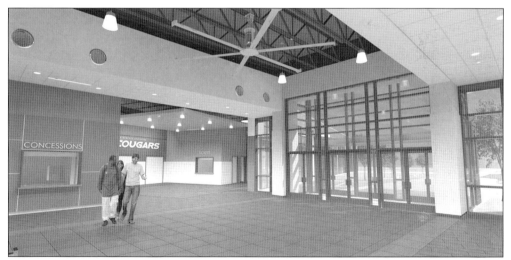

The entry to the arena will open to a grand atrium. There will be concession spaces both inside and outside for games that take place on the nearby fields. A press box with all the equipment to host regional and national tournaments is planned. The center will be an exciting addition to the campus and will provide new resources to the students and the community.